101 THINGS I DON'T KNOW ABOUT ART

An Opinionated Introduction to the Fine Arts

MICHAEL NAPOLIELLO JR.

Co-founder, Gallery C

Collector's Committee,
Los Angeles County Museum of Art

Board of Directors,
Pasadena Museum of California Art

Literary Press

Newport Beach, California
www.literarypress.com

Published by Literary Press
Newport Beach, California
800-339-0551
www.literarypress.com

Library of Congress Control No. 2004108195
ISBN 0-9716958-6-5

Dedication

For the late Michael Napoliello, Sr., Teacher

Contents

Acknowledgments

This book could not have been written without the love and support of Shannon Harold.

Thanks go to my business partner and friend of two decades, Jason Moskowitz; to my team at Gallery C; artists Ron Pastucha, Andy Moses; and PMCA Director, Wesley Jessup; PMCA Founders, Bob and Arlene Oltman; my editor, Robert Woodcox; and the authors of the outstanding books noted in my Resource Section.

My aim was to encourage art appreciation and debate through important and entertaining questions and insights. Where this book is helpful, much credit goes to the above. Where I have missed the mark, it is my fault entirely.

Introduction

This book was a labor of love. It is an introduction to some of the art world's most interesting enigmas (albeit a highly opinionated one). It is also a confession that despite being one who should know (based on a life long study of the arts and despite being the co-owner of a contemporary art gallery), I still spend a great deal of time scratching my head trying to decipher the mysteries and the search for truth that *are* the great works of art.

This book also reveals my dismay when I see how some esoteric academics, out-of-touch institutions, spineless critics, celebrity obsessed curators, career obsessed artists and bottom line dealers can drain the spirit and wonder from the world of art.

I promise that within these pages, I will give you my honest opinion and not attempt to make my conjecture professional dogma or sport (by sport I mean I will not try to convince you that *my* take on the players and the game is the sure bet).

For convenience, I have placed the 101 "things" into three categories: Ideas, History and Today. Sometimes they are stand-alone thoughts, and at other times, they are connected. You may find your own connections herein, as well.

Enjoy.

Ideas

One reason for the explosion in what counts as art is that the art world itself has taken up the old theme of getting "art" and "life" back together.

— Larry Shiner

The word "idea," comes from the ancient Greek, "to see."

— Michael Napoliello

One

If you consider the economics, the stigma, and the work environment, I don't know why anyone would want to be an artist. But every artist I have ever spoken with tells me they are drawn to the act of creating—what they call: working. Perhaps legendary American artist and teacher Robert Henri best expressed the lure of the artistic calling: The artist, he said, "finds gain in the work itself, not outside of it." Contemporary painter Ed Moses comments on the results: "The reward is discovery through process. What is found may be what I am looking for . . . the physical evidence and not the intention . . . that's what I'm talking about."

Two

I don't know if there is a precise definition of art. Why is a rusted metal beam by Richard Serra a work of art, and the same thing in a scrap heap, a piece of junk? It does seem to me that an artist seeks to create a unique—as opposed to mass-produced—object, even if it's only by virtue of a signature. He/she is also trying to express something personal. A great piece of sculpture will seem to carry on a lifelong conversation with you, and you alone. A highway guardrail, on the other hand, will (hopefully) not.

Three

I never really know (though I am asked in my gallery all the time) if this or that work of art is a "good deal." But, before I answer, I always consider four points. If the artist is dedicated, if the work is really well made, if it is a truly original image, and, above all, if you like it even more the second time you see it, I think it's a "good bet."

Four

I'm sorry, but I don't understand most of the art theory that I read. As for today's post-modern theory: I am completely baffled. I do find Clive Bell's thoughts, penned more than eighty years ago, very helpful. He said, and I paraphrase, that all artists start by trying to solve a problem of vision. For example, how would you draw motion, how would you paint emotion, how would you sculpt the fullness and the emptiness of the moon, the fragility of a women's face, the strength? Each time you see a work of art, ask yourself: What problem did the artist try to solve, and how well do you feel she solved it? I think that is the heart of all theories: pre-, post-, or some *modern* yet to come.

Five

I don't know why people sometimes feel uncomfortable with abstract art. I can understand how they feel, though. We want to understand our world, so we look for the familiar. We say this looks like that. That patch of Rothko blue could be the sea. That hazy burst of Rothko orange above could be the sunset. That's okay. That's one way to look at it. But, when we see a sunset, we don't ask ourselves: What does that sunset look like? A sunset is a sunset. A phenomenon of nature. Beautiful, sometimes. Ominous, sometimes. An inspiration for a memory, sometimes. Perhaps that abstract painting can just be what it is. A phenomenon. Beautiful. Ominous. An inspiring presence. A memory that may last a lifetime.

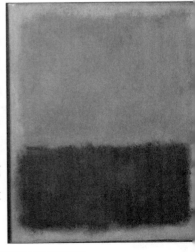

ROTHKO, *Untitled, 1960–61*, Oil on canvas

Whenever someone used to approach me in a gallery and ask: "What do you see in that? . . . " it would give me instant cause for panic. After much deliberation, I have decided on: "I don't know." Well, really, there are three answers I give: (1) I see what the artist is trying to express (about which, even if the artist himself knew, I would inevitably be wrong). (2) I see what I see, which will, at best, be a reaction to the chardonnay and a critic I just spoke to, or a momentary revelation that I will discard over time as a snake sheds its skin (so that the work of art will reveal something new.) (3) I see one person approaching another, standing before a strange image, searching for meaning. That one, for me, is the magic.

Seven

Why is one artist successful and another, of equal skill, impoverished? There are social and political reasons, of course. And there is the business of art and its machinations. I become feverish when I try to contemplate the whys and wherefores of any artist's bio. It helps me to remember that of all vocations, the artist's depends, most gravely, on equal portions of talent and luck. When I look at a work of art, I think on this and admire all true artists for their courage—to face their genius and their fate.

Eight

I don't think there is a precise use of the word nature. For example, when a river, which is nature, carves a canyon out of stone, this is said to be "natural." When a man, which is nature, carves a figure out of rock, it is called "idol." I believe that they are both the same thing. Of course, by this logic, it can be said that a bridge or a can of beer is nature. In truth, I have seen some wonderful art inspired by bridges and cans of beer. Monet and Johns—both forces of nature—come to mind.

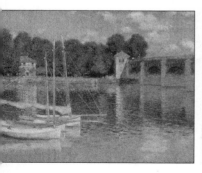

MONET, *The Bridge at Argenteuil*, 1847, Oil on canvas; JOHNS, *Ale Cans*, 1964, Lithograph

Nine

I don't know why people feel the need to display art in their homes. The critic Edward Goldman told me something to the effect that the art we choose is like a mirror that reflects what's in our soul. I like that. Mirrors of glass reflect our body. Art reflects our spirit. Of course, maybe it just looks nice above the couch. Or maybe we are simply trying to impress our friends ("come on over and see my etchings"). Regardless, displaying art in our dwellings connects us to all of human history—from caves to palaces, from tribes to New York City—each time we place a piece of art beneath our roofs, we are forging our links to humankind, no matter who we are or where we are from.

Ten

I don't know what people are driving at (and I don't think I want to know) when they look at a piece of deceptively simple art and say, "I could have done that." I usually respond, "But you didn't." To which they respond, "But I could have." I just bite my lip and think about the infinite distance between *could* and *did*.

Eleven

Who is my favorite artist? There are two reasons why this question makes my tongue fall out: First, art is a visual sensation. Look at Velasquez' Pope and the interpretation of that work by Francis Bacon—I love both. The second reason is the question itself. *Favorite* is often interpreted as *better*—especially when that question is put to historians, critics, gallery owners (like me), etc. Keep in mind . . . favorite is not better. Let's talk about "sensation!"

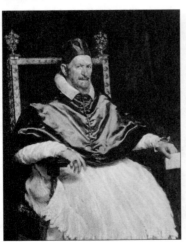 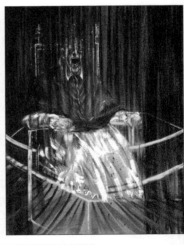

VELASQUEZ, *Pope Innocent X*, 1660, Oil on canvas; BACON, *Study after Velasquez's Pope Innocent X*, 1950, Oil on canvas

Twelve

Is there a hierarchy (or, a king, as it were) of art mediums in the world of fine arts? Yes and no. Painting seems to attract the greatest number of admirers and have the most powerful influence on other arts (paintings also usually sell for more money than their artistic cousins). Modern painters, such as Mondrian, influenced architecture. Picasso's paintings inspired a revolution in sculpture. The surrealists' influence on poetry and theater . . . and minimilist artists' influence on orchestral music, are still felt today.

On the other hand, sculpture and poetry survive as some of civilization's oldest and most seminal works. And what of the new? Performance, multimedia, digital art, etc. It is probably best to look at the medium's "appropriateness" (for lack of a better word) for the idea/image/feeling it is used to express. We can see perfection in Michelangelo's use of stone for his sculpture,

Slave, and can imagine no better medium than film/music for Godfrey Reggio's *Koyaanisqatsi.*

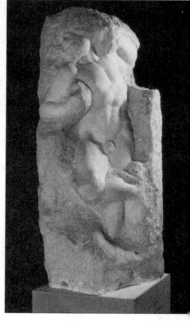

MONDRIAN, *Broadway Boogie Woogie*, 1943, Oil on canvas;
MICHELANGELO, *Slave (Awakening Slave)*, 1513, Marble

Thirteen

What are the defining characteristics of the artist's vocation? As art evolves to be ever more inclusive and thus indefinable, it becomes harder to answer this question in any universal way. Painter Andy Moses inspired in me a few thoughts, three of which, for me, have taken hold:

The true artist works alone. Even when he has assistants, he is the sole master of his task; he is not a collaborator (not even, in the final analysis, with his partners/customers/patrons. As, for example, an architect or an actor might be.)

The artist sets his own task. (This is a unique characteristic, considering the corporate/cooperative nature of our society.)

An artist's output deals with visual sensation. This seems obvious on the surface, but the visual has provided an axis for every artistic revolution and counterrevolution—by this I mean, no matter

how many times artists have revolted (against "painting," "the object," "materials," etc.), they have always revolved around the visual.

Fourteen

Are certain artistic themes/subjects more important than others? Yes and no (although it depends on who, and when you ask). Historically, "yes"—but debate has crept upon us over the centuries. Today, the "no's" hold sway. I refer you, for example to Clive Bell's seminal book, *After Cézanne* (1922), in which he tells us that our admiration for a statue of a god, or of a peasant, should be based only on its "execution." What matters is not the subject, but the quality and perfection of the work. Created by the chisel or brush of a master, the undulation of a robe, the tilting of a head, can inspire us, be they Jesus' or John Doe's.

A work of fine art's profundity should be, according to Bell, corporeal, not symbolic. Poet William Carlos Williams, perhaps inspired by early twentieth century painters (champions of execution), said it best with "no ideas but in things." Art in the latter half of the twentieth century, which largely abandoned the thing (object) for the idea

(concept), vis-à-vis performance art, minimalism, etc., seems to, on the surface, refute Mr. Bell and Mr. Williams. But, the concepts they rendered were not ones of hierarchal, symbolic icons, but universal actions. Simply put, "it is what it is." This is very Bell/Williams. What I have seen of today's fine art further asserts this axiom.

However, the future of art, as I have oft said, is anybody's guess—so the subject of "importance of subject" will remain open. I am a fan of Clive Bell, so I believe the subject is only the premise and not the purpose of painting and sculpture. Regardless of the past and of what the future brings, looking at what you're looking at for what (and how) it *is*, and not what it *means*, can be an enjoyable experience, indeed.

One day, the allegory, the myth, the history piece may return. Then, too, there is also a subject no one has ever dreamed of . . . yet . . . but an artist is dreaming it right now.

Fifteen

Where is the best place to discover talented new artists? I have to reply: Where is the best place to see the sky? It is constantly changing and never quite what you expect when you arrive. Cities tend to congregate talented people, but worthless lemmings as well. Art schools can nurture the rare genius, but, as likely, the posers. Studios in low rent districts provide artists shelter, but not often the experience and exposure that helps to refine their talents.

Contemporary art museums and exhibitions will bill themselves as representing "the new," and they can provide convenient access to a wide body of work. More than likely though, you will discover only what is already popular. If this all sounds frustrating, it is. Like treasure hunting, it's all part of the danger *and* the charm. The best tip I can offer is one that has served me well over the years: Ask established artists. Curators and instructors can be helpful, too. But established

artists will be most aware and desirous to support your quest. They, more than any, believe the new artists represent their true legacy—the ongoing search for, in the words of the poet, truth and beauty.

Sixteen

Sometimes people ask me whether an artist's early—or later—works should be considered more. I have no idea. My experience tells me it is best to consider an artist's body of work as a whole. My heart says: Jesus the carpenter, Jesus the healer—I would like to have known both.

Seventeen

Why is the authenticity of a work of art so important? For example, an authentic sketch by Rembrandt would be priceless, and an identical work by a no-name artist (or worse, a forger) would be nearly worthless. As I write this, the media is covering the story of a woman who found a Jackson Pollock at a garage sale. Art experts and forensic scientists (checking fingerprints and DNA on the frame, canvas, etc.) are trying to verify this. If it is an original, it will be a multimillion-dollar masterpiece, and, if it is a fake, a dollar store curiosity.

This is a very difficult question because it goes right to the heart of the "What is art?" debate. If it is simply a visual experience, a signature would be meaningless (similar works would be similarly priced/appreciated). On the other hand, if the work *is* a commodity, art would be sold in souvenir shops like celebrity autographs. I call this problem the "biographic quandary." The work (the tangible graphic element), should speak for itself; but the

artist's history ("bio," as it's known in the art world) adds to the value of the work. This makes the most sense when art is looked at as an investment (surely the work of an artist with a great bio will be more likely to go up in price). From a purely fundamental (aesthetic) analysis, however, it makes no sense at all. So how do we resolve this twisty paradox? There are a few areas we can investigate. (1) We can consider the idea propagated in the 1970s by the performance artists—their contention was that art was not just the object but, rather, evidence of a performance by the artist. (2) Madison Avenue would be another place to study—why is a brand name worth so much more than a knockoff? (3) I also suggest we go back to the original purpose of art itself: art as fingerprint—read: I am here. (4) Finally, I believe that artists somehow inject their personality into their work as their work injects its realities into them. Over time, an original work, like its author, will grow ever more special—as only the comparison to fine wine could describe.

Eighteen

If we saw a Da Vinci painting (or Jackson Pollock, for that matter) in a pizza parlor, would it have the same importance as it would on the wall of a grand museum? Or, is its placement in a museum that which bestows status on a work of art?

Most artists, and the purists among their fans, would say that the work has inherent quality. But, both would agree that museums impact the renown of said work. Museums—as keepers of public trust—would defend their objectivity and transparency in regards to the course of art history, all the while, working on a multitude of (non-art related) commercial/political levels to raise the status of the institution.

Here, please indulge me in an analogy: a statue of Jesus on the dashboard of a taxicab; a statue of Jesus in a monumental cathedral. The importance of the icon is the same. The likeness may be identical. The message is precisely the same. But the experience will be completely different.

Architecture, exclusivity, and reputation play important roles in our perception of art. The question here—the unique (independent) sanctity of art versus the power of the museum—is important. A definitive answer will not be forthcoming. As the role of art/museum in society evolves, the debate will be ongoing. Perhaps it is most helpful for our time here to simply be aware of the fact that *place* affects experience. As Christopher Knight (*Los Angeles Times* art critic and one who should know) reminds us: "Context confers meaning." To know who controls the place and to what ends is relevant. To appreciate the design and the accessibility of the place is important. At the beginning and end of this debate is the hope to see, clearly—without prejudice—the connection between the art and the place. I do not think this will necessarily "demystify" the artist or the museum. Rather, I think it will make us see art as continually being part of our time and place.

Nineteen

We have all read of the clamor caused by the artist Marcel Duchamp presenting a standard urinal as sculpture (in a piece called *Fountain*, 1917.) Although years have dulled the shock, we still ponder Duchamp's purpose—insult or inspiration? Joke or genius? In all: Is it art? Since there are more theories then agreements—and the best I can do is say that contradictions are part of the modern artist's palette—I will share an insight from author/curator Manfred Schneckenburger: "In the end," he notes, "art is in the eye of the beholder." Inasmuch as Duchamp's work explores the possibility that the idea of art depends on a sort of collusion between the artist and the observer, and, in the broader scope, between artists and the public, this can be inspiring in that we become historically connected to art.

By the same token, it can be disheartening in that our heroes (the artists) and our teachers (the critics) lose some of their mystique. Ultimately,

Duchamp, god or jester, made it clear that look-
ing at art (and in truth, looking) is active, as
opposed to passive, viewing. Whether we like it or
not, the struggle to form an aesthetic point-of-
view is a struggle we share with the artist.

Late in 2003, I gave a lecture wherein I noted the wondrous similarity between the just released *Hubble Telescope* photos of a distant (2,500 light years away) star nebula, and Jackson Pollock's colorful "drip" paintings of the early 1950s. Right away, someone in the audience asked me how I thought Jackson did it: "Did he have some cosmic insight?" Jackson Pollock's paintings, those childlike explosions of color, caused much consternation in their day. Major press and audiences alike asked questions like: Genius? Foolish? Masterpiece? Hoax? In truth, there are still people today, when confronting a Pollock, who consider it meaningless splatter.

However, time has proved the value of the paintings, and the Pollock legend continues to grow. So it seems appropriate to me that this question of "cosmic insight" (the type of thing one often asks of a Da Vinci), is asked with honest respect and awe. Unfortunately, I cannot answer for certain.

Art historians speak of Pollock's being inspired by Picasso's endless quest for originality. But Pollock's originality does not necessarily point to a clue of this connection to space photos. Pollock himself spoke of his love of the outdoors and the downright bucolic location of his East Hampton studio being a great inspiration for his work. But he was speaking of more earthbound sky and landscapes. The pre-space-age science of Pollock's day did not have the technology to see great distances—astronomers never imagined what star nebulae looked like.

A possible explanation comes from the way Pollock painted. He would put his canvas on the ground. With sticks in his hands dripping paint, he would walk on top of the canvas, and, with only a loose vision of where he was going, in an energetic and purposeful dance around and around the canvas, he would let the paint fly. His freedom from easel and predetermined figures enabled him to become dervish-like—free to let

momentum and gravity, inspiration and chance, instinct and surprise hold sway. He was not representing nature . . . he *was* nature—less like an astronomer, more like the cosmos into which he peered.

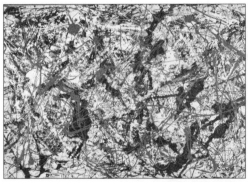

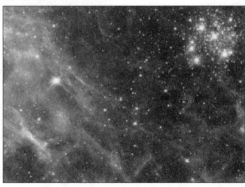

POLLOCK, *#22*, 1949, Oil on canvas; *Tarantula Nebula*, Hubble telescope image

Twenty-One

The art of Monet, "unfinished." Cézanne, "madness." Matisse, "bestial." Picasso, "ugly." Henri, "garbage." Bacon, "awful." Rauschenberg, "shocking." Serra, "infamous." Why, in its day, is breakthrough work of genius almost universally derided? Indeed, why is it that, as Clement Greenberg said, "All profoundly original art looks ugly at first"? And not just landmark art of the last 100 years, but seminal work down through the centuries. The perspective of Giotto (fourteenth). The passionate realism of Caravaggio (early seventeenth). The severity of David (eighteenth), all suffered similar derision. Ultimately, history has avowed all of these artists, "masters." But why such vehement opposition when their work first appeared? It is so common that reasons like, "Well, that's just how people are, stand pat. But there is much more to the game, and the stakes are high. There are the common sense explanations. We are social animals. There is comfort in the pack—leading to a predictably

conservative viewpoint. The unfamiliar must be perceived, at first, as dangerous. Mavericks, by our nature, are eschewed. The fact that today's avant-garde so often becomes yesterday's respected tradition, seems to be lost on our social minds.

We are also jealous beings. If we are not afraid, we may be envious. This goes for artists as well as the public. Art is also a business, and inasmuch, suffers from the same negative reactions to "disruptive" innovation as any business. There is a high cost/risk to change—never an easy thing to embrace (see *The Innovator's Dilemma* by Clayton Christensen). A fresh and unique insight comes from Donald D. Hoffman's book, *Visual Intelligence*, in which Hoffman reminds us that the mind making sense out of visual input is a monumental psycho-physiological effort. Simply, its hard enough for the brain to discern a dangerous animal from a tumbleweed, a pillow from a rock—and you want it to deal with Picasso, too?

Anatomically, dealing with new optical stimuli is grueling. If you consider painting in two dimensions and void of any other sensual function (most galleries prefer you don't touch or smell the paintings)—the difficulty of making sense out of it, what I call mental calisthenics, increases.

Perhaps we should cut ourselves a break for constantly misunderstanding the new Van Goghs. Interestingly, this fear of the new does not necessarily proliferate all phenomena—it seems to stick to the world of art. "New and improved" is a beloved mantra on Madison Avenue. We heartily embrace innovative leisure products and have a passion for new household items—for example, the IPOD is a huge success. No problem at all with new drugs. Travel to "new and exotic" destinations is a hot ticket. We can't seem to get enough of radical change in fashion. We celebrate it every year (try to get a hotel room in New York City during "Fashion Week"). For whatever reason, new

breakthroughs in art begin their lives as strange treasures buried in our mental landscape—the hunt feels perilous. Can we know precisely why? No. It is a combination of the noted reasons, and reasons we have yet to uncover. Is there a treasure map? Maybe. Awareness of the phenomena may help us more quickly find the benefit/pleasure in new art.

Like many things that are enhanced by experience, when we finally start to get good at "hunting" the new, we appreciate the genius of it—and we start to enjoy it. Joy is why it was created. Joy is why it's important.

Twenty-two

Spotting important, new artistic trends can be fun and profitable. Is there a way to do this consistently? Probably not without a crystal ball. Do not be disheartened—the best experts usually do is from hindsight. Most "schools," "isms," "movements," and "hot developments" are missed or misinterpreted while they are happening. For the lucky few who are there and actually see and experience them, it can be a life-changing joyride (read John Bernard Myers' story).

What are some of the things we can do to increase our perception? Art consultant Sugar Brown encourages us to look at major societal trends to anticipate important movements in art. "Cutting-edge art," she says, "is always a result of what is going on economically, politically, etc." Dynamic times/events anticipate powerful artistic conflux. For example, have a look at liberal/wealthy Florence's influence on the experimentation and grand projects of the early Renaissance.

The Industrial Revolution jump-started the cataclysmic, motion-obsessed work of the Futurists. America's mid-century materialism and consumer excesses presaged Pop Art. If you look closely at the world and think critically about where the action is, you might find a new style of art emerging.

Today, emerging artists feel the gravity of terrorism, global culture, a growing economic divide, new democracies, celebrity-obsessed culture, disruptive technology—where will all this lead? To get close, visit artists' studios in different parts of the world and notice coincidental similarities. Such expressions, appearing consistently, may define an emerging vision. Art school galleries can provide a glimpse of the future. Major movements, though they seem to come out of a cosmic void, are generally connected to the recent past, either as a perfection of, or rebellion against, previous trends (a continuing or perpendicular connection)—so look for the angles between

adjacent generations. Group studio spaces provide a convenient place to talk innovation with multiple artists. Something deceptively simple as a development in paint may have a profound effect on the future. The invention of oil paint (which Vasari credits to Flemish artist Jan Van Eyck) may have single-handedly sparked the Baroque! Imagine what digital will do!

Go to exhibitions. Exhibitions produced by artists will often be more "honestly" insightful than shows produced by professional promoters. Be wary of auction houses and their post-auction press—too often self-serving and late to the party. Art magazines and newspapers can be useful—but probably not as much as an often-overlooked source: books. The research and resources necessary to publish a book will provide a certain level of vision and veracity. Check out the later chapters of *The Art Dealers*, by Laura De Coppett. Publishers like Taschen and Rizzoli produce picture-filled

monographs that provide a wealth of objective information about young artists. And, hey, you can always take a critic to lunch—they *love* to share their valuable insights (but please be prepared to pick up the bill!)

It would have been something to stroll over to the Bateau-Lavoir and recognize the young Picasso; to party in New York with a fresh-faced Warhol, to be the first ones to see video and graffiti in the light of a new art scene. *Fantastic!* Something is happening right now that will blow yesterday away—and it is just around the corner. Let's go!

Twenty-three

How does an artist know when his or her work is "finished"? For some, there are technical considerations. Work in certain mediums must be completed within a specific timeframe. Imagine you are a sixteenth century fresco artist painting on wet plaster, or, in a modern studio utilizing a blend of fast-drying acrylics. In either case: When it's dry, you're done! Other materials, like resins and costly cast metals, have similar limitations. However, typically, material concerns are less significant (most mediums are pliant or the artist can simply start again).

Here, artists rely primarily on their experience and feelings. The legendary British artist, Francis Bacon, summed it up for many when he said "Instinct!" Bacon often told inquirers that his paintings were done when he deeply felt that he could do no more.

Contemporary LA/NY based painter, Andy Moses, echoes this sentiment when he says he "just

knows." He adds, "It's similar to how you know when you fall in love with someone." Other artists believe that fundamentally, their works can never be truly finished. The influential minimalist artist, Barnett Newman, reflected, "I think a man spends his whole lifetime painting one picture or working on one piece of sculpture."

The vibrant, empty spaces and exposed canvas in paintings by Gerhard Altenbourg, and Shusaka Arakawa remind us that art, like life, is a work-in-progress. Still, the idea of completion has deep roots in the universal ideal of perfection. Artists strive for "objective" beauty. We have all seen paintings by fifteenth century master Botticelli and wondered at their perfection. Everything seems to have its place. It is impossible to imagine the work any other way. There is veracity, harmony, and beauty. If one thing were to be changed, the work would be destroyed.

Centuries away (chronologically and visually), On Kawara's picture, *August 14, 1975,* shares the same ambition—and curiously demonstrates its enigmatic nature. Be the artist driven by material concerns, instincts, the rush of the moment, or philosophy, the struggle for satisfactory completion is ongoing. As the character, Monsieur Frenhofer, the esteemed painter in Balzac's novella, *The Unknown Masterpiece,* said: "Show you my work! No, no it must still be brought to perfection." Balzac somberly reminds us that we will never see that particular painting.

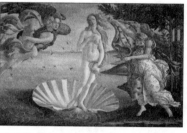

SANDRO BOTTICELLI, *The Birth of Venus,* 1485, Oil on canvas; ON KAWARA, *August 14, 1975,* 1975, Oil on canvas

Twenty-four

What advice can be given a young artist? Much. None. Yes, there is a road—but it is a road with a thousand turns, each a contradiction. Three turns are encountered often: mentors, business sense, and originality—each a passageway, each a wall. Have a look. It is true that artists can learn best from other artists. A young artist can do well to seek out the insights of an artist they admire, a mentor—yet they will most likely find more questions than answers.

Museum director Robert J. Abbott suggests focusing on a "business plan" (a traditionally weak area for most artists). But art world gadfly Mat Gleason recalls that: No cover letter ever landed an artist a gallery show.

And then there is the modern mantra urging: Be original—a woeful truth for a young talent struggling with technical immaturity and art history. Yes, advice is often needed and appreciated—and

there is honor in sharing wisdom, but it is perhaps best to advise the advisor. Hippocrates comes to mind: First do no harm.

Twenty-five

What constitutes a masterpiece? On the surface, this is a simple question. As you may have expected then, it is most difficult to answer. The American Heritage dictionary definition, "An outstanding work of art" tells us nothing about the qualities of that art. Understanding is further skewed by our points of view. The historic view (institutional or critical agreement), at best, provides social opinion. Fundamental analysis (which attempts to establish a purely aesthetic framework) is, at present, inherently subjective.

In his important book, *The Invention of Art*, Professor Larry Shiner reminds us that, prior to the eighteenth century (or thereabouts), things were simpler. "Originally" Shiner points out, "a masterpiece was the piece by which an artist demonstrated to the guild that he or she was now a master of the art." The idea of "masterpiece" as a demonstration of an artist's best work continued for centuries. In the last few (post-guild)

centuries, as the idea of artist transformed from artisan to creator, the term masterpiece has taken on a deeper, but more intangible meaning.

To define masterpiece, we must define artistic creation in the quintessential sense—an effort fraught with intellectual peril. We can agree that masterpiece should mean a great artist's best work. How do we define *great artist*? *Best work*? At least one truism has survived the centuries: that of a masterpiece "standing the test of time." However, that then leads us to another question.

Twenty-six

What period of time is needed to recognize a masterpiece? An anecdotal survey—tales of the unrecognized geniuses discovered after their death; the great "century" retrospectives; the breathtaking auction prices for works whose authors were "penniless" in their day—would lead us to believe that great spans of time must pass. Surely, then, we think time must be necessary to "prove" an art masterpiece. Or is it? In fact, Raphael was recognized as a masterful painter from his first commission (an altarpiece he executed at the ripe old age of eighteen). Pope Julius II, Michelangelo's infamous patron, recognized Michelangelo's skill with brush even before the artist did. (Michelangelo feared he was not qualified to fresco the Sistine Chapel's ceiling—"thank God" for the Pope's urging.) Rodin was much loved in his day and often called "the greatest." There is also the legend of Picasso's master work, *Les Demoiselles*. Picasso felt the work was incomplete and, like Balzac's tragic character

Frenhofer, kept working on the piece in endless, private torment. Picasso's peers, however, when allowed a glimpse of this "work-in-progress" immediately recognized its masterpiece status.

Clearly, there is no formula. There are artists, like Botticelli, whose masterpieces took centuries to be recognized (believe it or not); Rousseau, who waited decades; Utrillo, still waiting; Pollock, years; Basquiat, hours; and Borofsky, perhaps needing a little longer. The thrust of it is: No one wants to be fooled by first impressions. By the same token, no one wants to miss the chance to recognize a contemporary masterpiece in their lifetime. This is true for experts and novices. The takeaway: Neither time nor reputation is a crutch. Past, present, and future (hopefully) will be blessed by masterful work. Perhaps, sooner or later, that work will be blessed by someone's astute and daring eye.

Twenty-seven

What is the most important innovation in the history of fine art? In our language, the term innovation is inextricably linked to technology. And indeed, it is vis-à-vis technology that many of art's most cataclysmic changes happen. The development of metal tools and casting had a profound effect on sculpture. Prepared pigments and canvases expanded the possibilities and popularity of painting. The impact of digital technologies are just beginning to be realized. More subtle, yet perhaps most profound, are aesthetic developments. The evolution of perspective, color theory, liberation of subject matter, and abstraction are advances that shook-up thousands of years of tradition. It is quite possible that the greatest change was wrought by the invisible hand of 18th century philosophy, for it is during this period (notes Larry Shiner in his seminal book, *The Invention of Art*), that the idea of artist transformed from craftsman to creator. Representation gave way to inspiration. The

artist became less servant, more god. The intellectual, spiritual, and social developments that enabled this intellectual leap can fill many a book.

Suffice it to say that since this new way of thinking, a flood of genius was unloosed and the art world has never been the same. I believe all of these changes are simply precursors to remarkable things to come. It is the first time in history that technical, aesthetic, and philosophical innovation is being freely embraced by artists and (most of) the world at large. Let's leave our discussion of today with: The greatest innovation is the spirit of innovation.

Twenty-eight

Is there a universal standard for ethics in contemporary art? It would not surprise me to hear an immediate, guttural "no" shouted by a public shocked by Manet's *Olympia*, revolted by Serrano's *Piss Christ*, and tortured by Dror Feiler and Gunilla Sköld Feiler and their *Snow White and the Madness of Truth* (when it was unveiled in Stockholm this year, this riveting installation about the ethos of suicide bombers so angered Israel's ambassador to Sweden that he physically damaged it).

Yet, the act of creating inherently produces an ethical point-of-view. Whether the artist intends it or not, he/she takes a stand (in support of, in question of, or in defiance of), the ethics of their time. For example, Native Indians (for good) and Nazis (for evil) created work that underscored their beliefs. American art in the 1960s and '70s consistently questioned popular mores. And throughout history, artists were often on the attack. If we bear this in mind—that no endeavor

is more passionately connected to ethics than art—a strange paradox emerges: the dependence on and revolt against ethics. If there is a canon of ethics, it is to test the canon. It is a good sign, indeed, that this question is so difficult to answer. Since ethics, at their core, are rules of social engagement, our society is well served by artists questioning these rules—so that these very rules remain a path to freedom, not a prison.

Twenty-nine

Photography has been the red-headed stepchild of the art world since its birth in 1839. Attractive, yet so different from the traditional fine arts, no one knew what to make of it, so for its first 100 years of life, photography was cast out.

Critics, including artistic and intellectual luminaries like Baudelaire and Santayana, argued that cameras were simply reproduction "machines" and photographers more akin to graphic artists. Nevertheless, at the dawn of the twentieth century, the creative and promotional talents of Alfred Stieglitz brought the aesthetic possibilities of photography into focus. Although fine artists and connoisseurs began to embrace photography as one of the family, the art world at large, evidenced by the minuscule number of galleries and serious collectors, still viewed photography as a second-class citizen.

Today, that is radically changing. Around the world, there has been a burst of new galleries

specializing in photography (such as the Barbara Mathes Gallery and the Robert Koch Gallery). There are two exciting international "first annual" exhibitions kicking-off in 2004: Photo-New York and Photo-London. Major fine arts museums are adding contemporary photography to their collections. Prices for historic photos (including Stieglitz's early work), avant-garde (such as Man Ray), modern documentary (such as the Bechers), and even young guns (like Wolfgang Tillmans), are on the rise. This is, of course, thanks in no small part to a fresh wave of high-profile collectors like Bruce and Nancy Berman, Robert Fisher, Elton John, Baron Philippe Lambert, Thomas H. Lee, and Ann Tenenbaum.

The art press is buzzing with excitement. Does all this mean that photography can finally rest easy in the bosom of the fine arts? I'm not so sure. There are still many pundits who feel that the rise of photography is an anomaly. Collectors may cool. Artists may abandon the form. It is notewor-

thy to say that today, more than ever, photography and fine art are standing face-to-face. Any minute now, if we watch closely, we may see who blinks first.

Thirty

Maverick Japanese painter/sculpture Yoshitomo Nara has been called a lot of things—punk, rebel, star—and now, *popular brand?* Having just picked up a wonderful set of Yoshitomo Cup Kid toys from a local gift shop, I started thinking about the distinction between the commercial and the fine arts. By licensing his images to make bookends, dolls, etc., does Nara compromise his artistic integrity? We can expand the question to include everything from Gustav Klimt refrigerator magnets to (my favorite) Renoir poker chips.

On the plus side, there is no question that inexpensive commercial reproductions bring artistic images to the widest possible audience. It could be argued that a mouse pad Mona Lisa is better than no Mona Lisa at all. Detractors fear the fall of civilization—well, just about. Purist concern might revolve around the importance of the medium. By taking Renoir (for example) from canvas to

laser printed poker chips, the image is disseminated but not the experience—the common/ popular context lacks the "sacred" quality that the original, large format oil can impart.

Similarly, I fear, the artist's original motives are not represented well by these other products—no matter how much I like my Andy Warhol sneakers. There is also the issue of control. When an artist, an agent, an artist's estate grants reproduction rights to a pen company, a yoyo maker, etc., our concept of "What is art?" is shattered. Still, I am all for fun and a world full of exquisite images. And why shouldn't artists profit from the attractiveness of their work? While artistic icons have been cheaply reproduced in various forms for the pleasure of the masses (and the profits of their producers) for centuries, there was always an understanding that this was sort of a devil's bargain.

Today, according to international art correspondent Kay Itoi, some artists "seem to disregard the

line between the fine and commercial arts." At the very least, artist and public seem to find themselves in a world where that line is blurred. Perhaps the question for this millennium will not so much be "What is art?" But, rather, "What is art for?"

Thirty-one

The Wadsworth Athenaeum Museum of Art (Hartford, Connecticut) recently launched a fantastic exhibition: Surrealism & Modernism—an intimate survey of this exciting period, including such Masters as Calder, Cornell, Dali, de Kooning, Magritte, Matisse, Picasso, Pollock, and Rivera. What I enjoyed most during my visit was that this modest show includes their lesser-known works as well as "blockbusters." In fact, the "lesser knowns" were often more compelling than the biggies. Yet, while watching the crowds, I noticed that Salvador Dali's subtle and exquisite landscape, *Paranoiac-astral Image* (for example), is overlooked for his ever-popular *Apparition of Face and Fruit Dish on a Beach*. Joseph Cornell's *Homage to the Romantic Ballet* is similarly rushed over for *Untitled (for Juan Gris)*. And even between two artists, we find the popular Picasso (*The Bather*) overshadowing a much better picture in the same genre, Rivera's *Young Girl with a Mask*.

In a broader scope, this can be said for many works in the Prado (where *Guernica* dominants the modern galleries), the Louvre (the *Mona Lisa*), etc. This got me wondering: Is the foundation of popularity simply familiarity (much like it is with music, celebrity, and major brands)? I am not critical of this point. It is indeed pleasing to glance at an icon that so many have stood before in a similar respect. We must keep in mind, however, that this tells us little about the fundamental quality of the work.

Warhol's soup cans, among the most recognizable art works in the world, can be cited to illuminate this debate. It is important to ask ourselves if we are being drawn to a work of art because of the art, or because of the critics and promoters that have helped bring these works to prominence. The enigma deepens when you consider that even the noted blockbuster works were poorly received in their day (and purchased for a few

hundred dollars in today's money!). Let's go back to our original question—is a work of art's greatness based on its familiarity? Since taste, which so greatly effects art appreciation, is a complicated recipe made up of internal and external factors, the question remains part of the magic of the art experience. Since a complete answer is not forthcoming, I suggest, as we wander the galleries, we simply enjoy the question.

Thirty-two

While recently looking at Ray Martin Abeyta's paintings at the Hispanic Cultural Center (Albuquerque, New Mexico), I was, like reviewer Nikita Storm, mesmerized by "all their beauty and detail." Suddenly, I became conscious of the words "Hispanic art" filling my head. A term neither aesthetically or geographically relevant (such as cubist or Mexican), I wondered why it has taken on such significance. Major museums have Hispanic wings, major cities have Hispanic art museums, and major collectors boast of their "Hispanic acquisitions." But considering the size of the global Hispanic population, the diversity of artistic styles and their far-flung countries of origin, shouldn't Hispanic art just be called *art*?

Perhaps there is some value to cultural typing. It can draw our attention to artists and places that may have been overlooked. It can point out interesting historical facts and aesthetic details—deepening our appreciation of the work. But it

can also propagate stereotyping that prejudices our perspective on the work—that is, good "Hispanic art" is somehow different (perhaps lesser) than good art.

It is best to be suspicious of ethnic typing. We can let it lead us to exciting new artistic vistas, but it should never prejudice our experience. In the end, Hispanic art, outsider art, black art, feminist art, etc. is human art—it comes from the place where we are all completely different . . . and totally the same.

ABEYTA, *Rosario de Besos*, 2001, Oil on canvas

Thirty-three

We take the picture frame for granted. Most cities have more frame shops than art galleries. A painting without a frame (to illustrate my point) is called "unframed." Frames are so ubiquitous that to ask "why" seems superfluous. But if we consider that the known history of art dates back nearly 40,000 years, and the frame (not even 1,000 years old) is a baby, the question is actually quite intriguing. There are no strong theories on the origins of frames. It remains a mystery why they started appearing around the thirteenth century. I will venture that concurrent technological advances in woodworking tools, canvas manufacturing, and paint production had much to do with it. But, from a style perspective (why frame at all?), authority Werner Ehlich gives us one of the few clues when he suggests we look at the "connection to related items, such as doors, windows, and mirrors."

Conceptually, the "Why frame?" question is even more interesting. There are those, like renowned American painter Thomas Cole (1801–1848), that profess, "The frame is the soul of the painting" enhancing the painting's qualities and affirming its separate existence from the world around it (Kant's "Parergon").

Other artists, such as Jackson Pollock, would disagree, believing that a work of art is not a separate reality (from the world around it) nor is it, like a mirror, a reflection of reality. These artists see a work of art as a unique, natural phenomenon, connected to the whole of life. To these artists (not unlike artists for the first 39,000 years of art's history), the frame simply makes no sense. And, yet, here we are, trying to make sense of it all.

Thirty-four

What is the best way to prepare for an art auction? Now that's a loaded question! I won't review in detail the widely available rigmarole except to say that, yes, it is a good idea to know as much as possible about the piece that interests you; know what you think it is worth; establish your bid limit; and, most of all, observe as many auctions as possible before you "go live." What you do not hear in typical advice regimen is the tale of the winner's curse. Auctions, by their nature, are geared toward extracting the highest price for the object in question. In nearly 80 percent of the cases, the winning bidder overpays. While auction house techniques, such as public relations, promotions, bid minimums, etc. play a part in this, human nature is the primary culprit. Put simply, we love to compete for the objects of our desire, and, most often, in the heat of the moment, we will let down our rationale facilities and lift up our paddles in frantic bidding.

This happens in all types of art auctions, not just at the major houses. Bottom line: This game is ruled more by psychology than art/business savvy. So how does one prepare one's mind? I have some tricks that work for me. I like to know "the room" (the layout, who the other bidders are, what the style of the auctioneer is). And I try, as much as possible, to be prepared "to walk" (good advice when buying a car, too). But overall, advice for auction preparation is like diet advice— simple to understand, nearly impossible to practice. Sold!

Thirty-five

These days, according to critic Roberta Smith, Installation Art is "everybody's favorite medium." And so it seems that at the dawn of the twenty-first century, "installation" is hot and, as Russian practitioner Ilya Kabakov noted, poised to replace "the icon, the fresco, and the painting." But isn't installation simply a type of sculpture? The question is important because in defining a new genre, we skew our perception of the work in question and impact cultural developments (i.e., the establishment of museums, schools, galleries, publications, etc.). I believe that installation is a fresh branch of sculpture involving traditional and nontraditional materials and, most notably, incorporating a specific place and audience (as participant) into the finished work. Some experts disagree, stating that sculpture's true focus is the manipulation of materials, while installation is medium-neutral and primarily concerned with the viewer's experience. I am not sure medium and experience can be separated in this way.

Contemporary sculptor Jonathan Borofsky's talking sculptures could easily be called "installation." Installation artist Juame Plensa's works, especially *Love Sounds I–V*, are profoundly sculptural. Confusing, isn't it? Where do we go from here? Inspired by the installation process, sculptures are enjoying limitless new possibilities. Through the study of conventional sculpture, contemporary installation artists (such as Juan Munoz, Hew Locke, Ernesto Neto, Ian Treasure and Michael McMillen), are adding evermore creative dimen-

sions to their work. Whether this exotic new style is an outgrowth of tradition or truly its own genre, time will tell. Regardless, we are in the most exciting time in the history of sculpture.

Viewers startled by Ian Treasure's installation, *Scissor Piece*, (motorized scissors mobile, 2003). Photo courtesy of Gallery C.

Thirty-six

A unique fusion of minimalist abstraction and purported profound subject matter, Barnett Newman's painting, *Stations of the Cross*, is one of the supreme enigmas of twentieth century art. Bare canvas stretched to fourteen-equally-sized panels, each with only a combination of vertical black lines (Newman called them "zips"). *Stations* (currently housed in the National Gallery of Art, Washington, D.C.) is as nonrepresentational as a painting can get. So from where does the subject matter, the *Passion of Christ*, or what Newman described as "the unanswerable question of human suffering" come? Clearly, by naming the work *Stations* (subtitled *Lema Sabachtani*, Hebrew for "Why did you forsake me?"), Newman intended to make a literal connection; and executing fourteen panels creates a physical connection to the traditional Christian icon.

The long vertical zips have been called symbolic of the verticality of the cross, and their upward thrust has been poetically described as the upright nature of man and his potential for spiritual ascension.

Mary Swanson (professor of Art History at the Center for Catholic Studies, University of St. Thomas) suggests we look at the work in the context of the iconographic history of the Roman Catholic Church. All of this seems to belie abstraction's formalist aim and the "it is what it is and not something else" mantra. Moreover, if the work looks to me more like a representation of prison windows or jet trails, as opposed to the fall and rise of the son of man, am I wrong?

The possibilities here are many. Meaning comes from the author's statement. Meaning comes from the display tradition. Meaning comes from history and context. Meaning comes from the viewer's imagination. All of these theories present interesting contradictions, such as: If Newman had titled

the work *Black Rain* (for example), would it no longer be *Stations*? If we are unfamiliar with a picture's lineage or display conceits will it lose its communicative abilities? (There is also the Emperor has no clothes theory—there is simply nothing there—see Donald Kuspit's book, *The End of Art*.)

Can we simply decide that a representational image of Christ on the cross means something else? How can a picture be both what the artist says it is, and what I say is? If it can't, who wins? If it can, what happens to reality? We can go on . . . but I'm sure you see where this is leading.

Let me just end with a curious fact provided by eminent brain scientist, Dr. Michael Salcman, who reminds us that Barnett Newman's paintings "are more frequently subjected to physical assault than any other objects in modern museums." Perhaps you and I are not the only ones fershimmiled by this question.

Thirty-seven

What will the art museum of the future look like? This is what makes the future fun—because you never know. Museums today differ from their predecessors in many ways. There are numerous smaller museums with a focus on a certain period or genre, as opposed to the 19th century chronological mode of presenting art history. And museums today, also tend to produce a schedule of thematic shows—sort of an intersection of history and entertainment. Experts see this trend continuing with a further emphasis on the "ahistorical" exhibit (focusing on the connections between, as Harald Szeemann notes, "Works from what may be very distant periods and cultures"). I also think the museum will have to become more mobile—what curator Hans-ulrich Obrist described as a "network" for showing art in different spaces "bridging the gulf between art and life." (Pioneer efforts by Obrist include an exhibi-

tion of contemporary art in his kitchen and one he presented on an airliner.)

The Los Angeles County Museum of Art is developing ways to partner with cutting-edge commercial exhibitions. The Boston Museum of Fine Arts recently loaned a collection of Monets to the Bellagio Hotel in Las Vegas. Big museums will probably grow bigger (MOMA in New York), and small museums will probably grow smaller, like the Small Museum of Contemporary Art— SMOCA (I kid you not!) in Springfield, Missouri.

The museum may also go through an academic paradigm shift (noted by McKenzie Wark of the Macquarie University, Sydney, Australia) from an archival institution to a "keeper of the future in the sense that what the museum presents . . . is a sample . . . of what artists will make of the future."

Museums will also need to adapt to the demands of new mediums such as video, installation, virtual art, etc. Today, most museums have Web

sites. In the future, the Web may become an extension of the museum. More than just an online slideshow, it is my hope that the digital domain will be part of the museum's "architecture" and, at some time in the future, there may be a universal interface that provides quality access to all museums' (typically out of reach) riches—New York's Metropolitan Museum of Art's "Timeline Project," funded by Robert and Harriet Heilbrunn, is a fun, first step. Regardless of what the future brings, Szeemann implores us not to forget that the museum's primary job is to house and protect the fragile treasure that is art.

Thirty-eight

In the past, arts were generally separated into temporal (theater, music, poetry) and spatial/material (sculpture, painting, etc.) Today, artists are questioning the role of time in material arts. Time, not as a literal subject (as can be seen in the surrealists), but as a real component of the work.

Self, a bust by artist Marc Quinn (purchased by vanguard collector Charles Saatchi), is sculpted from nine pints of the artist's own, frozen blood. The work exists as long as it is frozen "in time." Similarly, David Hammon presents real snowballs as art. Douglas Gordon's infamous *24-Hour Psycho* (where the two-hour Hitchcock film is spooled out over twenty-four hours and the entire assemblage—projector, film, image—is presented as installation), examines the effects of time on reality in a relativistic universe.

UK artist Darren Almond goes straight at it with his piece *Meantime*—a giant digital clock. Painter and multimedia artist Jonathan Borofsky presents

his works, vis-à-vis a unique (although some would say obsessive) numbering system, as a chronological unfolding.

Other contemporary painters are experimenting with time-encoded substrates and paints (designed to change over time or last a specific period). Do these and similar developments signal a new era in fine arts where time becomes an essential medium? It would not be surprising, considering the interest these works have garnered. The idea is fresh and new.

Artists today are embracing materials and modes (digital, installation, and so forth) that lend themselves to the investigation of time. The "hottest" scientific theories today present time and space as a singular, pliable component of reality—all perfect ingredients for a "movement."

Still, there is no critical evidence of a movement per se (i.e., historic analysis, thematic exhibition, artist

manifesto—though a near hit can be seen in Gustav Metzger's writing on *Auto-Destructive* art).

There is also argument that, at best, these efforts are minor developments within traditional genres (video, sculpture, and the like) or, at worst, clever gimmicks. And while the public is intrigued, collectors find the works enigmatic and demanding (rumor has it that Saatchi's refrigerator was accidentally unplugged, destroying Quinn's head—oops!).

I can say that "time as material" is an exciting development and warrants a close look. And if you are enjoying the perplexity, just for fun, I offer a thought from one of today's most important physicists, Brian Greene: "In due course, space and time as currently conceived may be recognized as mere allusions to more subtle, more profound, and more fundamental principles underlying physical reality." Seems like contemporary artists may be heading in the right direction.

Thirty-nine

Is the avant-garde dead? There are many difficulties in answering this question. While everyone agrees on a definition of the term (French for "advance guard"—denoting artists that use innovative or experimental techniques, often to challenge existing art/social norms), few agree on who or what the avant-garde was/is. The reclusive genius Paul Gauguin was called avant-garde, as was contemporary multimedia artist and pop music icon, Laurie Anderson.

Early nineteenth century German Bauhaus and 1970's American performance artists have also shared the label. Today, for better or worse, almost any young talent or new group of artists, wear the crown. In these latter examples, the avant-garde itself has become (some say "boring") status quo—hurling it into a state of (if not death) suspended animation. Moreover, previous avant-garde movements have been white, male, Euro-dominant.

The rise of minority/outsider arts have blown the lid off comfortable labels. Also, the idea of art as history—with its inevitable tides and avant-garde cross-current—has given way to an "ahistorical" view (discussed elsewhere in this book). The impact of this is summed up by internationally acclaimed artist-philosopher Hervé Fischer when he notes: "The crisis of avant-garde ideology, which began in the late 1970s, marked an end to the grand era in which all artists believed themselves to be signing a new page in a great, heroic 'history of art'." Ultimately, alive, dead, many today feel that the question is irrelevant. Art, they say, is not war, science or politics. Inasmuch, the advance guard is "leading" us nowhere in particular—it is, rather, a kaleidoscope. By this diagnosis, avant-garde is certainly on ice. But we may be looking at it the wrong way. Avant-garde may not be a process or state of being, but a spirit—the spirit to embrace and master new technologies (such as digital artists, today),

or the spirit to experiment in order to find new solutions to current problems (such as installation artists), or perhaps the spirit to think of original solutions to age-old issues (such as contemporary feminist artists), and the spirit to challenge oppressive social institutions with utopian visions (as third world and minority artists do everyday).

I have witnessed this in the work of Albert Oehlen (Germany), Ernesto Neto (Brazil), Daniele Buetti (Switzerland), and Bodys Isek Kingelez (Congo). Perhaps "dead or alive" was the wrong question. Let us end at the beginning with a new definition of avant-garde: the fight for something for which to be alive.

Forty

Time period: today. Scene: any art gallery. Place: anywhere. Why am *I* here? Why are *you* here? Why are *we* here? By all appearances, we are amidst a "community" of people around the world who are interested in art, but in our hearts we know there is more.

Some of us are here for business (artists, collectors, critics, and dealers might fall into this group). Some are here to meet interesting people (people who are interested in art are *interesting*, aren't they?), okay, then good-looking people? Some are here for the ubiquitous "free" white wine. Others are here to see who is here. And still others are here because they hate/love art. Of course, this list is not complete, and the categories are not exclusive. This is what makes the question so compelling and quizzical. Perhaps the visual arts are simply a stage setting for a play in which we can all partake, or perhaps there is some truth to the romantic notion of the sacred

in art. My own contention harkens back to ancient travelers visiting legendary Oracles. Uncertain of where they were heading or the destiny that awaited them, they would come, with offerings, for a glance at their fate. (Did I mention the free wine?)

Forty-one

Is the connection between Earthworks (a 1960 art movement typified by artist Robert Smithson's *Spiral Jetty*) and Native American "mound builders" valid? I'm not sure. In two dimensions, it is a simple question. Both are artistic constructs. They have no particular usefulness beyond the decorative. Both can be strikingly beautiful and demonstrate incredible craftsmanship. They also share process, scale, and material similarities. The differences, I believe, are highlighted by motivation and function.

Tribal artists, practicing some 4,000 years ago, created thousands of these earthen monuments throughout North America. It is likely, though, that their motivation was social edict, and their purpose conformed to pre-established ritual. This by no means diminishes the accomplishment (one of the largest works, near St. Louis, Missouri, has a volume larger than that of the Great Pyramid).

Contemporary artists are motivated by their own inner politic. The goal may be to draw attention to the environment, create a new ritual, or a purely aesthetic one (the challenge of getting it done, the fundamental results). If we arrive at the same results via different means, are we talking about different art forms? Tough question, indeed. Contemporary earth-artist Agnes Denes

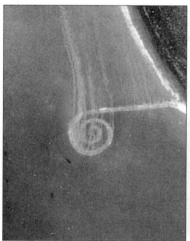 describes her work very differently from her native forbearers. I will leave you with her

SMITHSON, *Spiral Jetty*, 1970, mud and rocks, 1,500' tall by 1,500' wide (aerial photo); NATIVE AMERICAN (for example) *The Great Serpent Mound*, circa 1000 B.D., aerial photo

words from *Wheatfield—A Confrontation* (1992): "My work . . . deals with controversial global issues, questioning the status quo and the endless contradictions we seem to accept into our lives— namely, our ability to see so much and understand so little"

Forty-two

I have no idea what the technical basis of a "good eye" is. I have noticed that the more art one looks at, over time, the more one can differentiate the ordinary from the extraordinary.

HISTORY

Creativity can bring together what is separated in and by history.

— Donald Kuspit

The term, art history, is an oxymoron. A work of artistic genius is an oracle, not an archive.

— Michael Napoliello

Forty-three

There are many theories about what prompted prehistoric man to paint caves (as far as we know, the first examples of "art"). What drove early man to create these images? Who really knows?

I am certain about two things, though: The drawings were useful, and they were an important form of information and communication.

Over the years, art has become more about "experience" than communication. However, I still find it exciting to stand before a painting, whether it be on a rock, wall, or on fine canvas and ask, "What are you trying to tell me?"

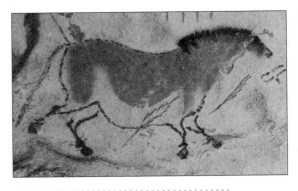

The "Chinese Horse," Prehistoric cave painting, Lascaux Caves, Perigord, Dordogne, France, dates to Prehistoric era

Forty-four

Throughout history, we have always felt the need to "rank" art and artists (Who was the greatest artist? What is the greatest piece of art?).

I've learned to think differently.

The comedian Jerry Seinfeld once made a telling comment when he was asked to compare several artists: "I don't know," he said, "Let's take 'um out back and race 'um'."

In reality, there are no scorecards. However, just for fun (and example), I offer this clash of titans: Suppose we compare Da Vinci and Picasso on three fronts: scope of output, projects completed, and influence on culture.

Scope of output: In this case, I would have to give the edge to the multitalented and multidimensional Leonardo.

Projects completed: Give the nod here to Picasso. His productivity was legendary.

In terms of which man influenced culture to the greatest extent: too close to call. Therefore, it appears we have a tie. If we even have to answer a question like this, I strongly suggest that only artists be allowed to vote. Of course, if we used those criteria, Julian Schnabel would vote for himself—so perhaps some things are better left unranked.

Forty-five

Why does art appear where and when it does? A typical travel guide through a timeline of art history would most likely start in ancient Greece and Egypt and then move on to Italy.

Though geographically close, it's a long chronological trip to France—and Paris, in particular. Add another fifty plus years and we can move on to New York and then Chicago. From there, we could journey to California (spending most of our time in San Francisco and Los Angeles).

Why has art taken this route? It's hard to say. Perhaps politics and public institutions have as much to do with this as do their alter egos—prejudice and economics. Resources and climate play a big role as well.

But there is nothing evolutionary or predictable about this journey. As I write this, Japan and India are emerging as art centers (so is Cincinnati, Ohio, if you can believe it). The treasures of South America and Africa are barely touched upon, and

it is difficult to imagine that Paris will never have another day in the sun.

What does this question teach us? Many things. The appearance of an abundance of art is not just blind luck or the grace of mythical gods. A society's support (or lack thereof) has much to do with the depth of artistic genius in that culture. Art also needs an audience (i.e., if a tree falls in the woods and no one hears it, did it make a sound?).

At the same time, critics can manipulate an audience for better or worse. As an example, the critic Clement Greenberg's championing of the young Jackson Pollack gave an enormous boost of confidence to many American artists. On the other hand, minority artists from around the globe are notoriously overlooked.

Trends play a part too: artist's, on the whole, are gregarious—they like to go where other artists are.

It is hopeful and exciting to think that anything is possible. The journey is, by no means, manifest. Where will the Paris of 1900 be in 3000? That is it somewhere is of the most important consequence.

Perhaps the most beloved of ancient art forms is the fresco. Even today, throngs of tourists throughout the world marvel at the fresco's beauty and grandeur. Whatever happened to this art form? Every time I wander Italy's great cities and gaze reverently upon the remains of these public masterpieces, I wonder the same thing.

Fresco, a unique type of wall/ceiling painting, is one of the oldest art forms known to man. Its origins can be traced to prehistoric cave drawings, Egyptian art, Near and Far East murals a half century before Christ, first century Pompeii decorative painting and, of course, the Renaissance masterpieces in Europe.

Italian luminaries Michelangelo (sixteenth century) and Tiepolo (seventeenth century) represent to me, the zenith of fresco painting. (According to the National Gallery of Art in Washington, D.C., the only example of Italian Renaissance frescos in

America are the Bernardino Luini imports, *Story of Procris* and *Cephalus*, circa 1520).

In the nineteenth century, after a span of thousands of years, frescos fell into decline. There has been much speculation, but little agreement on why. I believe that technology may have had more to do with it than the vagaries of taste.

Fresco is "pigment" painted on wet plaster. Usually, the plaster is applied to a stone wall. For most of history, it was far more economical to paint in this manner than to paint on a prepared, stretched piece of canvas or even wood.

As canvas and oil paints became cheaper, they became the media favored by various patrons. (A modern analogy would compare film to digital images.)

Ultimately, the laborious and immobile fresco fell into disfavor with both patrons and artists alike. Where does this technique stand today?

Most historians agree that fresco served two purposes: decoration and "propaganda" (the modern term for the latter being "advertising").

From a decorative standpoint, today's spirit of fresco can be seen in the super-sized canvases of contemporary artists such as James Rosenquist. A few contemporary artists, notably Francesco Clemente, have incorporated the technique into their newest works. There has also been a resurgence in the popularity of trompe l'oeil style frescos in private homes. (See the wonderful examples by Scott Waterman and Richard Haas, which are reproduced in Karen Chambers' book *Trompe L'oeil at Home.*)

There are also a number of organizations such as the Contemporary Fresco Painting Resource Center (*www.truefresco.com*) that teach and support contemporary fresco skills and projects.

Historically, examples of propaganda included public frescos promoting religion, royalty, national

legend and accomplishments, and even merchants' wares. My favorite example of the latter would be the *Fresco of Priapus*, on the entryway of a Pompeii brothel (scintillatingly reviewed online by *Science Daily*). In short, the importance of fresco as "advertising" should not be overlooked. Many credit the popular Mexican murals of the 1920s by Diego Rivera and David Siquerios for drawing attention to poverty and racism, as resurgence in fresco. In fact, during the depression of the 1930s, the U.S. government sponsored over 2,000 murals in public buildings (see *World Book* online).

A great example of this is the late artist Helen Lundeberg's massive (240-foot-long) mural, *History of Transportation*, which is currently being restored/saved from vandals and age. It will soon be returned to its birthplace in Inglewood, California.

As I write this, Las Vegas is drawing hundreds of artists to recreate the grandeur of fresco (for decorative and advertising purposes) on the walls of

super malls and mega casinos (think Sistine Chapel with gambling and cocktails—cool). In reality, then, it would appear that there hasn't been so much a decline in fresco, as much as a transformation.

Forty-seven

One of my favorite art history questions is, "Whatever happened to the halo?" In most of the great murals and paintings from the ancient Greek to early Renaissance, you could always spot the "good guys." They were the ones with bright circles around their heads (a bit like the white hats in Western movies).

The term halo, according to Sally Fisher in her entertaining book *The Square Halo and Other Mysteries of Western Art,* harkens back to depictions of the mythological Greek sun god, Helios. The rays that emanate from his crown represent the rays of the sun. Egyptian and Christian artists adopted and modified this icon, which eventually evolved into the floating disk, often gold colored that we see in classical paintings.

Overall, the halo is a literary symbol (circles and other perfect geometric shapes are metaphors for celestial perfection and spirituality). Different shapes conferred different status upon the wearer.

For example, according to Fisher, a square halo might tell us that the subject was believed to be headed toward sainthood. An almond shape was reserved for Jesus and Mary. However, Fisher says, "As the Renaissance progressed, the halo changed to a thin ring of light. This delicate ring suggests a new, sophisticated embarrassment about the whole idea of a halo."

I believe the abandonment of the halo was more than just a stylistic change. As medieval superstition gave way to Renaissance experimentation, artists such as Da Vinci and Rubens approached their art with a freedom unknown at the time.

From the seventeenth to the nineteenth century, artists struggled with good and evil in more earthbound themes, such as war, love, family, and nature (works by Rembrandt and Goya are particularly illustrative).

The modern era seemingly poured cement on the halo's well-nailed coffin. Modern artists eschewed

literary conceit of any kind for a more primary experience. The history of art, however, is a story of revolution and return. At the dawn of the twentieth century, surrealist artists like Salvador Dali introduced iconic symbolism into their work. These symbols were more psychological than mythological, and these artists infused a literary element into their work.

The surrealist connection to writers, from psychologist Carl Jung to poet Guillame Apollinaire, is well documented. The mid-twentieth century witnessed a backlash to such conventions. Artists like Mark Rothko and Jackson Pollock banished all figures and symbols from their work, essentially making any literal interpretation arbitrary.

Contemporary art gallery director Nancy Silverman-Miles tells us that symbols are back in vogue: from Pop artists' incorporation of icons, to Madison Avenue and folk art (Warhol and Basquiat come to mind), to a more personal symbolism seen

in the works of young artists such as Peter Doig, Karen Kilimnik, Jeff Koons, and Laura Owens. (An informative glimpse of their work can be seen in Taschen's gorgeous publication, *Art Now.*)

Will one of the artists, or perhaps an as yet unknown, reintroduce the halo? I doubt it, but my experience tells me that the great artists use the entire history of art as their inspiration and palette.

Forty-eight

Who opened the first truly modern art gallery space? This is an important and difficult question. How art is displayed affects our emotional experience and intellectual perspective. Through most of the history of art dealing, works were displayed salon fashion in what I refer to as "family room wall style," wherein traditionally framed work is displayed side-by-side and atop one another (its location often assigning its importance.)

The gallery itself may have looked like an exclusive cigar bar, a fine tailor shop, or a hotel ballroom with gilt-edged ceilings, fine woodwork, red velvet walls, and plush furniture. The well-to-do customer was welcome and at home, and the art was fashionable adornment for sale. While the modern art revolution raged for some fifty years prior to the first modern galleries, modern art was, at the time, sausaged into old-fashioned galleries. For the "new art," this most often resulted in poor aesthetic/commercial success. It wasn't

until the dawn of the twentieth century, and the influence of three young Americans—Alfred Stieglitz, Peggy Guggenheim, and Julien Levy—that galleries began to evolve into the format we are familiar with today—often dubbed: the white cube.

These three, very different and colorful characters, pioneered the modern art gallery. Walls were neutral, often painted simply in white. The space was open and uncluttered. Picture lighting and framing, or lack thereof, were tailored to the work, not to social custom. Artists were often involved with the layout of the installation (sometime to ingenious and comical ends—see anything Duchamp did, for example).

Of the three, Alfred Stieglitz's gallery, 291, came first (circa 1905). Stieglitz was *the* pioneer, though he was less committed to the moderns than the other two. Of equal importance was Peggy Guggenheim's, Art of This Century gallery

(opened in 1942). As the gallery's name implies, she was completely devoted to modern art, and her family wealth and personal social renown provided a public relations boon hitherto unknown in the gallery world. (Many of the classic modern masterpieces she showed can still be seen in her namesake museum, housed in a beautiful palazzo in Venice, Italy.)

Coming between Mr. Stieglitz and Ms. Guggenheim was Julien Levy's Gallery of Modern Art opened in 1931. In my opinion, Levy was the original as his gallery provided the perfect combination of Stieglitz's modern space and Guggenheim's commitment to modern artists and public relations.

History would give Stieglitz or Guggenheim (for her renown) the nod for being first. Of course, there is argument for either position. However, since it's my book, I say Levy. His ultra cool architecture, his commitment to modern artists, and his flair for, and amazing output of "buzz

generating" shows, make him the vanguard modern "gallerist." Yet, these three simply began the journey. It can be argued that the next generation of midtown New York dealers (especially Betty Parson, Sidney Janus, and Leo Castelli) truly planted the flag of modernism. Much credit also goes to Paula Cooper who, in 1968, was the first person to open a high-profile gallery in New York's now legendary downtown arts scene. Her cutting-edge, multimedia gallery epitomizes today's conception of the art gallery.

There is still space to pioneer, though. An example is Christian Hayes' establishment of The Project gallery in Harlem (1998) featuring unprecedented presentations of global art.

The modern gallery, with its sterile, minimalist interior design and universal sameness, which bestows an other worldliness on the art and artist, does have its detractors. Brian O'Doherty, in his insightful, groundbreaking study on the ideology

of modern galleries in his book *Inside the White Cube,* decries their alienating effect. "The modern gallery is," he says, "a ghetto space, a survival compound, a proto-museum with a direct line to the timeless, a set of conditions, an attitude, a place deprived of location, a reflex to the bald curtain wall, a magic chamber, a concentration of mind, maybe a mistake."

I agree with much of what he says; however, he is roundly critical and fails to appreciate the fact that there is some white magic here. First and foremost is that the gallery revolution followed the modern artistic revolution—in short, the new art needed a new home. Is the "white cube" the perfect solution? No—but the pioneers noted here made a quantum leap when a leap was called for. It also needs to be pointed out that the modern gallerist was an entrepreneur and, as such, relied on his or her own personal savvy and broad public appeal to survive—this created a popularizing effect on

modern art at a time when such attention wa sorely needed.

Imagine the art world in the 1950s withou Alfred, Julien, or Peggy. These galleries also changed museums forever—the recent modern ization of the Louvre, thematic shows at MOMA and the Geffen at MOCA in Los Angeles, are jus a few examples of many.

In truth, we may yet see the first modern gallery Today, galleries from California to the Far East are innovating in ways never imagined by their fore runners. Architects and artists are working together to improve the viewer experience. In my own gallery, we have experimented with glass dis play surfaces, mobile walls, custom hanging systems, and even acoustics to make the space a multi-sensory journey for experiencing art.

Vorpal Gallery in San Francisco installed a "bed area" where you can lie down to view art in a more personal space. Chiaroscuro gallery in Santa Fe

New Mexico, combined indigenous architecture with modern technology to give the gallery a true sense of place while brilliantly presenting contemporary works of art.

Galleries in Japan and Taiwan are going beyond nationalist connections to do some of the first truly global shows. From space design to exhibitions, one thing is certain: Tradition has been replaced by exploration. We have those first modern galleries to thank for that.

Forty-nine

Is the Turner Prize helpful or just "hypeful"? Established in 1983, the Turner is the preeminent award for the year's most important young (under fifty) British artist. It continues to be a bellwether contemporary art event. The prize was founded by a group called Patrons of New Art to help buy new art for the Tate Gallery's collection, and to encourage wider interest in contemporary art (see *www.tate.org.*)

Over its twenty-year history, it seems like the Turner has been cursed. The artists chosen for the prize have continuously fascinated and infuriated the public, the press, the British government, and other artists. Elitist, delusional, political, commercial, useless, gender biased, bullshit, shocking, and outrageous, are just some of the banners whirling around the Turner.

The award has seen mass public appeal and public boredom, success and bankruptcy. It has been associated with artists that have gone on to do

great things, and not so great things. Relatively speaking, the prize is small (around $30,000). I want to tell you not to take such prizes, grants, awards, etc. seriously. Art is not a sport, and any subjective measure will fall prey to "organization mentality" (anathema to art in general).

Perhaps the prize is not cursed. Maybe the prize *is* the curse. There is merit in the position of those who say "run for the hills!" But I personally have to side with the first Turner winner, Simon Morley, when he noted that the Turner, in the end, is a good thing. "It brings," he wrote, "the small and parochial art world into brief contact with the vast and usually indifferent masses. As a result, it is entertaining and sometimes thought-provoking—even culturally significant—things can happen." Not a bad curse, indeed.

Can art be taught? No, according to Art Institute of Chicago professor James Elkins and many highly regarded artists. On the other hand, yes, if you believe countless art centers, schools, colleges, and teachers. The negative, illuminated by Elkins, can be boiled down to the contradictions inherent in programming an art teaching method and goal. To this, I would add the enigma of originality ("learning to be original" is a self-defeating proposition). Moreover, the case for technique-focused education is well founded but confounded, because, and I agree with Elkins here, "Instructors inherently behave as if they are 'teaching something more than technique'."

Is there any positive? I believe there is value to the career-based curriculum—in general, how to survive as an artist. (Unfortunately, the idea has not been widely embraced by academia.)

There is also something to be said for the supportive "atmosphere" of the learning center—artists

can be inspired by the company of other artists. But this often just leads to faddish "school" cliques. A mutually profitable arrangement (for artist and teacher) might be found in the age-old apprentice model.

Another positive development is the addition of art theory surveys to applied arts programs. A grass roots learning initiative with good encouraging results can be found in the rise of semi-commercial, group studio spaces, such as Art Explosion in San Francisco.

Regardless of one's stance, today there are more schools, more artists, and more "hard times" for artists than ever before. And the artwork seems no better for it. However, we should not be pessimistic. Even if a clear conclusion as to whether art can, or even should, be taught is not forthcoming, simply asking the question fosters much needed debate. The insights gleaned may be of great benefit to artistic endeavor.

There is one more thought I would add: I believe that human beings have a deep need to teach and be taught. Even if the "thing" to be taught and/or learned defies teaching, the student/mentor relationship can be inspiration to do so, in and of itself.

Fifty-one

In the art world, semantic debates send authorities into ill-fated fits—none more than the argument over the distinction between the terms "fine" and "decorative art."

As I write this, there may be a fight over Grayson Perry being awarded the vaunted Turner Prize for "fine art." (How dare they award a ceramist?) The standard definition of fine art is simple. Its primary motive is beauty. Decorative art's primary motive is utility. So why is the question so confounding? I blame Jean-Baptiste Carpeaux, the nineteenth century French sculptor, and his breathtaking marble statue, *Neapolitan Fisherboy* (with one of the world's most unforgettable faces); and living master of glass, Dale Chihuly, and pretty much everything he creates. I used to have a trick to help me form an opinion on the subject (extremely useful in curatorial conferences and at cocktail parties). When looking at a work of art where the fine/decorative distinction

is not so obvious, I try to evaluate how practical or antagonistic that work is to its surroundings. For example, an exquisitely decorative French tapestry or Grecian urn can turn a room or a garden into a paradise. On the other hand, a fine art masterpiece, such as a colorful Monet painting, is enhanced by a solitary vantage point. Although difficult to decorate with, it is a paradise in itself—pretty easy, right? Then along come my arch nemeses, Carpeaux and Chihuly. The *Fisherboy* practically cries out for a Romanesque garden, and what a garden it would become—sophisticated, yet wild, with a sea by its side, a touch of Eden, a child's laughter carried in the breeze.

There is no denying *Fisherboy*'s perfection as a decorative work. And yet, on a pedestal in the austere, gray marble emptiness of its current home at the National Gallery of Art, the work shines as a fine art masterpiece. Original, flawless, compelling, expressive—a sculpture's sculpture.

Let's jump forward 150 years or so to Chihuly's glass wonders, *Temple of the Moon* and *Temple of the Sun*. Expertly integrated into the design of the Atlantis Hotel's casino in Paradise Island, they transform a tourist enclave into an exciting palace. Their utilitarian value is unquestioned and amazing. They adorn; they provide exotic light; they add mirth and passion to the never-ending party they inspire. The casino is the perfect world to rule for these decorative gods! Yet, drag them out of their casino and stick them into some sterile white cube of a gallery and, lo and behold, they would take on a life of their own as fine examples of fine art.

Can we conclude by simply saying the terms "fine" and "decorative" are portable or useless? No. In my opinion, doing so can hinder the study and, sometimes, appreciation of art. It is better to say that a third definition is needed, but I implore you, dear readers, not to fret over definitions.

Boldly seek out art of genius that defies our meager intellectual confines. When you find it—revel. Mr. Perry would be pleased.

Fifty-two

Paul Cézanne (1839–1906) is generally considered one of the fathers of modern art, yet his subjects are mostly classical (portraits, still lifes)—what gives? This is a good question with many good, though incomplete answers. As an artist, Cézanne was the first to be fanatically dedicated to going beyond representation to what I like to call sensation. By sensation, I mean the artist's attempt to recreate the sensation one has upon seeing an object. If you would allow me a bit of poetry, he was less concerned with how the *mind* sees (like the impressionists) and more concerned with how the *heart* sees. To this end, he pioneered and/or combined techniques, such as design tension, emotive coloring, three-D imaging, and flattening perspective for breakthrough paintings that astounded and inspired Parisian artists—presaging movements, such as abstract expressionism, cubism, neo-plasticism, and many others under the modernist umbrella.

However, it is more than Cézanne's vision and talent that complete the picture. Two points should be considered in particular. First, the master was in the right place at the right time. Cézanne lived in and about Paris, when Paris was the crossroads of the art world. His genius would be noticed and propagated. Moreover, pre-world-war Europe was a land ripe for a revolution. Second, and perhaps most important and modern of all Cézanne's traits was that he liked to talk about art. Though it is said he generally eschewed the public at large, Cézanne loved to theorize with his intelligent patrons and share his ideas with admiring young artists. All of these reasons, taken as a whole, rightly point to Cézanne's pivotal role in the birth of modern art.

While the astute observer might overlook Cézanne for monsters of change like Picasso, Mondrian, and Kandinsky, they would be missing

much—according to me, yes, but more importantly, though, according to the aforementioned artists, and countless others, themselves.

Fifty-three

Who was the first modern painter? The problem starts with defining "modern." By my definition, what is modern both breaks with the past and influences the future. By this definition, votes must go to Giotto, who overthrew all of antiquity and Byzantine orthodoxy (that's thousands of years of momentum, folks!), to give birth to what has ever after been called, Western Painting. However, Giotto's revolution (like the impressionists a mere 500 years later) was primarily technical.

Pundits stress the importance of conceptual (new ideas in and about painting) as well as technical change. With this perspective, Picasso immediately comes to mind because he shattered Western Painting and sowed the seeds of every conceptual development thereafter. Many think the vote must go to Picasso's immediate predecessor, the artist who, in so many ways, laid the groundwork, the great Paul Cézanne. (It was

Cézanne, after all, who was featured in the Museum of Modern Art's first show in 1929.)

By nearly any standard, Jackson Pollock should be elected FMP. Like a baseball batter with a monstrous swing, Pollock knocked the skin right off the ball. Ironically, so unique and iconoclastic was Pollock's drip-laden "action painting" that his aesthetics, while attracting massive critical attention and countless fans, failed to be incorporated by many artists—the Pollock style remains an isolated phenomenon.

We should not overlook Pollock's forbearer, master painter John Marin, who, as author Dr. Carol Strickland reminds us, was Picasso's contemporary, and America's first abstract painter. His talent and innovation influenced American modernism for generations. (In an interesting aside: Bruce Robertson, LA County Museum of Art's chief curator for American art, has uncovered work by little known American artist Manierre

Dawson, who painted, in 1910, what may have been the world's first abstract paintings—but that's another book!)

So who is the FMP? As we look back, it's difficult to say. All of these geniuses participated in the creation of what we call modernism. Of course some young guns may one day come along and create a picture that makes us believe we are seeing a modern painting for the first time—how cool is that?

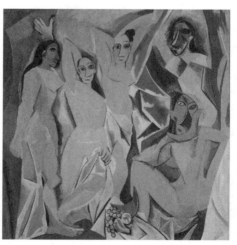

PICASSO, *Les Demoiselles*, 1907, Oil on canvas

Fifty-four

What is the greatest book ever written on art? While many a tree has suffered needlessly for worthless tomes, there are books that can actually add to the pure joy that is masterful art. Not wanting to be limited to my own library, I asked a number of colleagues to help me point them out. Here is what we can agree on:

Almost all discussions start with *Lives of the Painters, Sculptors, and Architects* by Giorgio Vasari. Not only did Vasari have an advanced critical mind and prodigious talent, he lived during the zenith of the Renaissance. Inasmuch, he is able to give firsthand perspective on his subjects—some of the greatest geniuses of any time. Best of all, his passion for the artists and their work has an evangelical effect. Vasari is still in print 400 plus years later, and still rolling.

In the same vein, published more than four centuries later, is John Bernard Myers' wonderful, firsthand account of the New York art world's

mid-twentieth century heyday, *Tracking the Marvelous*. Like Vasari, Myers is artist, critic, fan— if it can ever be said that a book on art is a page turner, this is it.

For better or worse, we cannot avoid inclusion of art critics/theorists. There are thousands, past and present. Approach them, cautiously, in this order: John Berger, Clive Bell, Meyer Schapiro. Berger writes in an approachable, carefree style. He connects art to the real world. He brings us to places that we may not have considered—sometimes places right under our noses. But, then, perhaps I should have said Bell first. Many artists and experts agree that Bell is the best art critic, period. With an economy of words, in a clear, friendly prose, he points out the strengths and challenges of turn of the century masters such as Cézanne. According to the *New York Times*, Schapiro "is the most important art historian America has produced."

I suggest reading these fine authors in the order given because Berger empowers us to see for ourselves, Bell is a user-friendly introduction to aesthetics, and Schapiro takes us to the next level. You may fall in love with art theory because of these guys.

I have, of course, not purposely snubbed the super champ of modernism, Clement Greenberg (well, okay, maybe just a little). His writings are major insights into modern art. But I find Greenberg to be somewhat esoteric. Worse, he has an agenda as a collector/tastemaker—which has impacted his perspective.

Perhaps a better way to approach critical theory is through *Theories of Modern Art* by Herschel B. Chipp. The genius of Chipp is that he lets the artists (through interviews, correspondence, essays) speak for themselves. Many of my colleagues consider this book invaluable.

The list must also include H. W. Janson's *History of Art*, although this colossal tome is really an encyclopedia.

Finally, there is a fiction work, *The Unknown Masterpiece*, by Honore de Balzac. The great Balzac takes us deep inside the head and tragic world of an artist intent on creating the perfect painting. With shocking insight and a passion, this short tale is a timeless revelation on the creative process. Someone once told me it was Picasso's favorite novel.

I know I have missed many important books. I am sure that if you and I finished them all, we would not agree on the best. We would each find many dead ends and many treasures. I hope you enjoy some of these that I have shared with you.

Fifty-five

Kostabi: Popular innovator or fine art assassin?

Ladies and gentlemen of the jury, have you reached a verdict?

In 1982, multitalented artist Mark Kostabi—obsessed with two conflicting subjects: artists and commercialism—moved to New York and took the burgeoning East Village art scene by storm. To tempt he founded Kostabi World—a studio, gallery, and office complex known for employing painting assistants and idea people.

Paintings are produced under the auspices of Mr. Kostabi—perhaps by his hand and design, perhaps not. Supporters say the attractiveness of the work, the daring of the process, and the Kostabi signature are all that matter. Select collectors and museums agree, including: The Museum of Modern Art; The Metropolitan Museum of Art; The Corcoran Gallery of Art, Washington, D.C.; Galleria Nazionale d'Arte Moderna, Rome; Duke

University Museum of Art; Groninger Museum, Holland; and more.

In 1988, according to expert Gregory Klages, Kostabi had thirty-four assistants, completed 2,000 paintings, and sold about $3.0 million worth of work. His paintings and other works are popular today. So, as *Flash Art* editor Giancarlo Politi once asked, "Why do so many hate Mark Kostabi?" It is as if his detractors blame him for the fall of Western civilization. Fraud. Schemer. Shameless. Promoter of "trash for cash." (These are their kinder comments.) Kostabi, they claim, is neither creating fine art nor penetrating the art/commodity issue—he is simply a salesman. His work may be likeable, but is it his work? Does it matter? Most believe it does. But there is historical precedent for Kostabi's modus operendi. Medieval painters

developed workshops and employed various assistants. Baroque masters tutored pupils on the virtue of reproducing classical styles. The great academies of the past few centuries propagated objective ideals, not personal creativity. Even the beloved Andy Warhol had his "factory" staff of artisans. So why indict Kostabi and not these?

I believe that time has simply forgiven great works of past ages. As long as a historic master-piece is "attributed" to someone, it can be revered. Warhol (and others of the pop ilk) clev-erly managed to aim critical focus at the ideas behind their work (as opposed to the work itself.) But Kostabi's art is so strangely attractive and compelling that we wish upon it the estab-lished purity of the artist's mind and hand. When we discover that Kostabi delivers his treas-ures unabashedly wrapped in an aura of smoke

and mirror, we are quick to anger. But it is exotic smoke. Breathtaking reflection. Can Kostabi be forgiven, ladies and gentlemen of the jury?

Fifty-six

When Vincent Van Gogh died in 1890, he left his brother, Theo, a painting: *Portrait of Dr. Gachet*. A few years later, the painting sold for about $58. In 1990, the *Portrait of Dr. Gachet* sold for a record $82.5 million. You read that right. And I hear you: How can a painting be worth that much money? From a purely financial standpoint (can a profit be made after the purchase—i.e., at auction), even a masterpiece is, at best, a speculative investment. Furthermore, a painting has no intrinsic economic worth. The paint, the canvas, the wood, represent little to no resale value. It is also impossible to put cash value on personal enjoyment. But there are other considerations. For example, Ryoei Saito, the Japanese businessman that purchased the aforementioned Van Gogh, hoped that the painting would bring attention and respect to his company and his country—but it didn't work out that way. The

company failed, Saito died, and the whereabouts of the painting are unknown. (Cynthia Saltzman wrote a great book about this.)

Powerful people and nations do, of course, benefit from the possession of a masterpiece. The value of publicity, tourism, and civic pride is not to be underestimated. A great work of art can also be good business. Major hotels and office buildings find that displaying important works of art can increase their revenues. Corporate art collections can be motivating to employees and, if they appreciate, add value to the bottom line. Also, a high price paid for a painting will, paradoxically, by drawing attention to it, protect it. Extra insurance, security, and care will be provided—helping preserve the work for future generations. (Upon painting the *Gachet* portrait, Van Gogh himself said: It may "perhaps be looked back on with

longing a hundred years later." He never knew how right he was.)

In the end, there are few objective standards one can use to value a painting. Cost of materials, as noted, is irrelevant. Things such as the artist's reputation and public appeal are important considerations, but difficult to translate into value. Interesting facts (i.e., the historic significance of the work, its provenance, etc.) are often noted when a high price is paid for a painting—still, it's difficult to peg a value to one.

Certainly, the type of art is relevant—oil paintings usually command higher prices than other works. This does not tell us why any work of art, especially a modest oil painting of a maudlin, run-of-the-mill doctor, would appreciate so astronomically in value. All explanations—auction fever, public relations, history, and/or investment

consideration—fall short. Therefore, it is a mystery. Perhaps the chance to have and hold a true mystery in our overly rational world may, in the final tally, be the prize consideration. Sold!

Note: At the time of this writing (2004), Picasso's *Garcon a la Pipe,* sold at auction for $104 million!

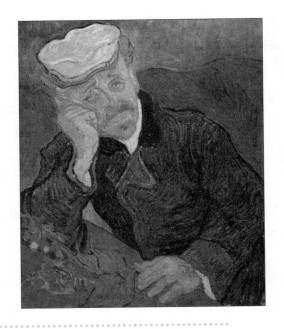

VAN GOGH, *Portrait of Dr. Grachet,* 1890, Oil on canvas

Fifty-seven

Throughout the career of American photographer Robert Mapplethorpe (1946–89), the challenging sexual content of his work was a source of critical tension. Nevertheless, he was recognized by pundits to be a true master—deserving of major museum exhibitions. In June of 1989, the Corcoran Gallery of Art in Washington, D.C., canceled a scheduled Mapplethorpe show. Former Congressman John Brademus (who, in 1997, was Chairman of President Bill Clinton's Committee on the Arts and Humanities) described the furor that followed: "The dispute leapt onto the pages of leading newspapers and magazines. Rival coalitions mobilized on the issue, with accusations of blasphemy and pornography from one side, censorship and thought control from the other. The debate in Congress produced proposals to alter the criteria the agency had used for nearly twenty-five years to judge grant applications." Proposals ranged from the grossly conservative to

the far-flung liberal. Bottom line, the Corcoran, even now, as recipient of public and government funds, has to consider its contributing constituencies (as well as art experts) when scheduling exhibitions. The conservative bias of the 1980s knocked the aforementioned Mapplethorpe show off its agenda.

Was canceling the show the right thing to do? As a disclaimer: I lived in D.C. in the '80s, and I desperately believe canceling was the wrong thing to do. I was personally disappointed. And, the Corcoran an important museum for showcasing newer art (in a town known for conservative, Euro-centric collections), never fully recovered its reputation because of the decision to cancel. The institution's stature has not been fully revived, despite the fact that many works by Mapplethorpe (as well as similarly vilified artists such as Andres Serrano and, a few years later, Karen Finley) have entered the Corcoran's permanent collection.

The issue is not an artistic one, however. If the public and the government are involved with an institution, it is impossible to completely turn its stewardship over to an independent staff. At the end of the day, the government and other donors are its "owners." But it is important to keep in mind that a museum's credibility is its value. Pandering to its constituents can be just as damaging as isolating them. What is the hapless museum director to do? It goes without saying, they must fight the good fight. They must find a way to create inviolate standards that cannot be manipulated after the fact. We as the public must keep an eye on appointees to key cultural institutions (such as the National Endowment for the Arts). We must elect officials that we believe will stand up for artistic freedom. This goes as high as the President. Am I overplaying the issue? Not when we remember that in that same decade, police raided the Contemporary Arts Center in

Cincinnati and, for exhibiting Mapplethorpe photographs, its director was indicted for obscenity. Is this the world in which we want to live? We must donate to institutions in which we believe. Join their committees. Get on their boards. Help educate children about the importance of art and the dangers of censorship.

Remember these words, spoken bravely by Mr. Brademus: "Proud as we are . . . of our economy or of our military might, we know, too, that the more enduring legacy of our wealth as a people is in the canvases of our painters, the songs of our composers and of our poets." Truer words were never spoken. The next time a Corcoran is at such a crossroads, will these words be heeded?

Fifty-eight

Is there a single greatest work of art of all time? True, I have often expressed my disregard for exclusionary questions like this—it is more important to consider an artist's work independent of academic prejudice or popular taste—please, no "Top 40" for the fine arts! However, this question is hard to resist. But, even if we ask just for fun, we run into the problem of defining *great*. Here are some examples adding to the enigma.

If we mean great by virtue of great invention, it is difficult to beat the *Venus of Willendorf* (when you consider this 27,000-year-old stone sculpture not only remains evocative, but may very well be the first human figure ever carved). *Great*, indeed!

For great beauty, let's go with the Lorenzo Ghiberti sculpted doors on the church of San Giovanni (created in the fifteenth century for Florence's oldest church). Michelangelo and Vasari both agreed that this work was unsurpassed in artistic beauty—and

I have never seen anything to prove them wrong.

The creation of an icon with the universal appeal of the *Mona Lisa* (c. 1506) would suggest its creator, Leonardo Da Vinci, is the author of the world's greatest work of art.

When it comes to scope (and no slouch in popularity), the title of greatest could easily go to Michelangelo's Sistine Chapel (c. 1512). If ultimate greatness is attributed to innovation, then we must also look at Picasso's legendary painting, *Les Demoiselles d'Avignon* (1907). Breakthrough technique. Unforgettable imagery. It created more than just cubism; it changed artists' conceptions of painting forever.

In a similar light, though less grandiose visually, is the revolutionary greatness of Marcel Duchamp's *Bicycle Wheel* (1913). Using everyday objects in his art (a stool, a wheel), Duchamp forever blurred the lines between art and reality. This

blurring has had a profound impact (some say "disastrous"—see Donald Kuspit's book *The End of Art)* on the public and artists ever since.

Fifty-nine

The first time you saw the *Garden of Earthly Delights*, you probably wondered what Bosch was smoking. I know I did. Little is known about this sixteenth century Dutch iconoclast; and he left no explanation for his blockbuster painting. I can say, however, that it is one of my all-time favorites—and, I bet, one of yours, too.

In fact, our fascination has inspired endless reams of ultimately futile interpretations. If I can be of any help, I might add "popular amusement" to an investigative trail currently dominated by "literary" (what was Bosch trying to say?) and "symbolic" (what did those images mean to the sixteenth century psyche?) research.

Most agree that Bosch's apocalyptic triptych was commissioned by a wealthy family. I propound, in the manner of a Hollywood movie producer, that the audience's desire may have simply been, amaze and frighten me. Bosch delivered. As with Hitchcock's murderous crows, Kubrick's odysseys,

and M. Night Shyamalan's signs—we are not so concerned about what they mean (beyond cocktail party posing and film school logorrhea), but how they make us feel—popular amusement, indeed. But I am certainly not comparing the Dutch master to Wes Craven—oh, then again, maybe I am.

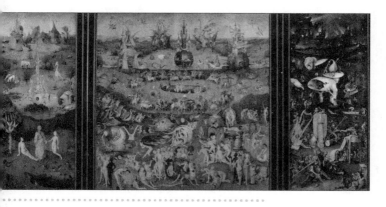

BOSCH, *Garden of Earthly Delights*, circa 1500, Oil on wood

Is Michelangelo's *Rondanini* pieta unfinished, or a Renaissance master's modern breakthrough? Michelangelo created a number of highly detailed pietas (a traditional Christian icon featuring Mary and the crucified Jesus) during his lifetime. He worked on the *Rondanini* until his death in 1564. Moreover, the evocative, life-size statue is uniquely rough-hewn compared to his earlier sculptures. These facts are strong circumstantial evidence that the *Rondanini* is simply incomplete. But it is possible that Michelangelo, having dazzled the world with his representational skills, was looking for something deeper, an inner vision of the subject's emotion—a trademark of modern art. It is also interesting to note that the *Rondanini* was not a commission. Michelangelo created the work for his own satisfaction—modern, indeed.

Most striking, but often overlooked, is the statue's side view. The figures seem to dissolve into pure geometry, a heavenly half oval, similar to Han.

Arp's modern masterpieces—created some 300 years later! Finally, there are the *Rondanini* cubist-like abstractions (especially at Jesus' right arm and shoulder, and the left side of his face.) These elements of emotion and abstraction are the hallmarks of modern art (considered a twentieth century invention.) It may be that Michelangelo can join company with Picasso. Or perhaps "modern" is not so much a time in history, but a place inside every artist's heart. Or, then again, perhaps Michelangelo simply ran out of time.

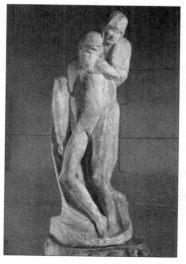

MICHELANGELO, *Rondanini pieta,* 1564, Marble

Sixty-one

As late as the nineteenth century, art and archi-tecture were one course of study. Slowly but surely, from the late nineteenth century to the mid-twentieth, they split (some would say to the detriment of both). Why? It is impossible to pin-point a cause. Experts note industrial era technologies that necessitated that architects focus on engineering over aesthetics. Philosophers during this period (especially in western cultures) also propounded a separation of utilitarian "crafts" from fine arts. On the heels of these developments, academic curriculums allowed students to specialize by occupation as opposed to fundamentals (it is difficult to imag-ine a modern university requiring architects to take a course in music or life drawing, as was com-mon during the Renaissance.) Adding to the rift were German pragmatists, American industrial-ists, English bureaucrats—each playing a part in breaking up the artistic family. But no one cause or body ever said "divide and conquer"—but

divide they did. Looking back, it seems that all of a sudden, after thousands of years, we have two professions: artist and architect.

Of course, there are fine artists today, such as Becky Guttin, that practice or influence architecture. And, there are architects who have created magnificent artistic statements—Richard Meier and Frank Gehry come to mind. But on the whole, the left hand does not know what the right hand is doing. Nowhere are the results of this situation more evident than in mid-twentieth century American architecture—functional, at best, totally artless at its typical worst.

Becky Guttin, *Mayas Cosmos,* at the Mexico City Science Museum, 1998, Iron sculpture

Art has suffered as well. Most architects today either (1) turn their backs on artists in the belie that architecture is art or (2) fail to incorporat fine arts into their building plans. While it is dif ficult to say definitively why these field separated, it is easy to see, all around us, why the inevitably must reunite.

Sixty-two

Is Rodney McMillian's *chair*, recently exhibited at Art Basel, the "Duchamp urinal" of the new millennium? A dilapidated, yellow easy chair McMillian found on the streets of Los Angeles, *chair* (McMillian uses the small "c") is regarded by some as a profound statement on age, loss, and the human condition—and a piece of garbage by others. Bemused upon first seeing *chair*, humorist Dave Barry was informed by an art expert: "*chair* offers not a weedy patina of desuetude but an apotheosis of its former occupant." In his nationally syndicated column, Barry, in response, wrote, "See, I missed that altogether, about the desuetude and the apotheosis. I thought it was just a crappy old junk chair some guy took off a trash pile and was now trying to sell for 2,800 clams."

Yes, it sure seems like 1917 all over again. What is art? What isn't art? And, if a urinal or a piece

of curbside garbage is art, how can we take art seriously? Are we taking art too seriously?

But there is a major difference between Duchamp's universal fixture of pristine, mass produced plumbing and McMillian's broken down chair—in its singular nature. There is only one chair like it. It has its own history. The artist chose it not for its universal, ready-made quality (as Duchamp sought), but because, like a human face or a view of a battle, it is one of a kind. McMillian could have created the chair to look exactly like it looks today (like Duane Hanson or Ed Keinholz did), but then its actual history would not have

RODNEY MCMILLIAN, *Chair*, 2003, Sculpture

been part of the artist's material palette. This "moment in time" element is an interesting difference between Duchamp and his young heir—where Duchamp's work speaks of art, McMillian's speaks of life (poor, exalted, or simply trash). Has McMillian found, on this Los Angeles curbside, an important new thread in the fabric of art; or, like the song says, is it just history repeating?

Sixty-three

Is early twentieth century modernism's radica
break from figurative art an anomaly or part of a
regular cycle of revolution and convention in the
arts? In the broadest sense, there have been two
periods in art history: pre-twentieth century figu
rative (emphasis on subject) and post-twentieth
century formal (emphasis on form). As Larry
Shiner notes, extraordinary industrial, social, and
scientific developments, as well as a growing
appreciation of arts from world cultures, encour
aged an incomparable spirit of experimentation
in modern artists.

Completely unprecedented manifestations (such
as abstraction, multiple points of view, atonality)
are all evidence that modernism is a one-of-a
kind transformation in the history of art. I believe
I could offer formulaic proof and concrete exam
ples to supplement my "feeling" that this period
is unique in history. Yet, it is hard to imagine that
peoples of the past did not think as I do now—

ertainly they could offer up their revolutions as
typical. Imagine living 4,000 years ago and see-
ng the first purely decorative sculpture. Or, 500
ears B.C., witnessing the birth, like a new star, of
ireek realism. Spine tingling chills must have
)een the order of the day when Giotto heralded
naturalism in the early 1300s. And let us not for-
;et the invention of perspective in the fifteenth
entury—that must have convinced everyone
hat art had reached its one true crossroad. And
vhat of installation art today? It is too early to
ook back, but I believe even Picasso would be
stonished. Suddenly, I am not so sure this ques-
ion is answerable. No doubt modernism was era

ICHTENSTEIN, *Bull IV,* 1973, Oil on canvas

making, even epochal. But if there was an equi table way to compare ages, there is room for the peoples of the past to challenge the innovation of the present—and just wait until the people o the future get a hold of us.

LICHTENSTEIN, *Bull V, Bull III, Bull II, Bull I,* , all 1973, Oil on canvas

Sixty-four

Is the work of Henry Ossawa Tanner (American b. 1859) the seminal "black art" (the first art deeply involved in exploring black cultural identity, as opposed to art simply created by African Americans)?

Tanner was one of the first African Americans to break with traditional European subjects that catered to popular white tastes. His early works challenged racial stereotypes and depicted African Americans in a solemn and honest manner. They were, in the words of historian Thomas Hampson, "classic statements of African American pride and dignity." In this, he was nearly alone in pre-WWII America. Overburdened by racism, Tanner moved to Paris where he spent his later years. He died in 1937 and slipped into obscurity during the ensuing decades. His expatriate status and lack of mid-twentieth century critical attention pressures the link between Tanner and the rise of black art. Moreover, many

of Tanner's most passionate paintings deal with secular themes—as opposed to his bolder and more consistently sociopolitical progenitors from the "Harlem Renaissance" (such as Palmer C. Hayden, Laura Wheeler Waring, and Jacob Lawrence). And, unlike Aaron Douglas (and his contemporaries) who expressed social consciousness through high profile public murals, Tanner's drawings and paintings are executed on a more intimate scale. Nor did he tackle the most radical political issues such as poverty and discrimination, as did Jacob Lawrence.

The daring and fame of late twentieth century artists has also served to shadow Tanner's star. Romare Bearden and Jean-Michel Basquiat—and to a lesser extent, Wadsworth Jarrell and Robert Colescott—have become heroes and household names. Young artists, such as the sensitive and brilliantly sardonic Kerry James Marshall and L.A. based Kori Newkirk, continue to tear the lid off

mainstream culture. Against this backdrop, it may be impossible to see Tanner's position clearly. Still, as an artist of great talent and courage—with unrelenting spiritual and social sensibilities—the first African American artist to attend the prestigious Pennsylvania Academy of Fine Arts—the first internationally honored—and the first to be exhibited in the Smithsonian Institution in Washington, D.C.—he certainly deserves another look.

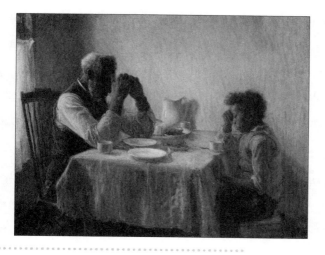

HENRY TANNER, *The Thankful Poor*, 1894, Oil on canvas

Sixty-five

An eager associate recently asked me a question I am sure he thought would find its way into this book: "Why is Mona Lisa smiling?" Sorry, my friend. Mona Lisa is smiling because Leonardo painted her that way. This did lead me, however, to another, more puzzling question—why are we smiling at the *Mona Lisa*? What I mean by that is: Why has the Mona Lisa attracted and amazed so many generations? I do not believe that, as many have conjectured, Mona (an Italian abbreviation for Mrs.) is a Da Vinci self-portrait. (She's *not* a man, baby!) And literary thrillers to the contrary, I do not believe she is a profound cryptogram. But she is surely more than a pretty face (and perfectly painted hands). To find out how much more, we can look at the painting's groundbreaking provenance.

Mona Lisa is one of history's first realistically painted women. And she is an ordinary woman at that. Neither deity nor myth, her beauty is

compellingly human. She is also painted in a (revolutionary for the time) candid pose—as timeless as it is breathtaking.

Also on Mona Lisa's list of firsts is her familiar size. As opposed to frescoes or miniatures, so popular in Da Vinci's day, the master artist conveyed a startling intimacy by embracing a more human scale. Then there is the fascinating history. We can imagine Leonardo parting with his beloved painting in an exchange with the French King, Francis I. We can envision how the *Mona Lisa* must have looked in the collection of Ludwig XIV—or on Napoleon's bedroom wall (until 1804 when she found a new home in the Louvre.)

Then she was stolen and taken to her birthplace in Italy. She was recovered and returned to France. She visited New York and Japan and caused massive traffic jams (or, at least, bigger traffic jams than usual). She was the inspiration for many more Mona Lisas (some with mustaches) by hundreds

of famous artists. And she has been reproduced (in countless forms) more than any other artwork in history.

All of this is too much, yet, not enough. There must be something more. I think it is that, with Mona Lisa, Leonardo Da Vinci masterfully achieved an aim familiar to all true artists—he rebuilt the tower of Babel. What has been impossible for language, and just out of reach for so many artists, can best be seen in this humble picture. The *Mona Lisa* is something people all over the world understand in a way that is both personal and universal. What do you think?

Sixty-six

Artemisia Gentileschi (b. Rome, 1593) was one of the first female artists to achieve recognition in the "male-dominated world of post-Renaissance art." Historian Larry Brash reminds us: "In an era when female artists were limited to portrait painting and imitative poses, she was the first woman to paint major historical and religious scenarios." The scope and quality of her work are undeniable. Biographer Kari Boyd McBride concurs: "Artemisia Gentileschi was the most important woman painter of Early Modern Europe by virtue of the excellence of her work, the originality of her treatment of traditional subjects, and the number of her paintings that have survived"

Her personal story of struggle and survival are equally amazing. She was raped when she was nineteen and attacked and humiliated in trial (and tortured in jail with thumbscrews) for having the "audacity" to place charges. She was systematically denied access to artistic apprenticeships (typical of

the gender bias of the times). Ultimately, she was self-taught. And while she faced, as we shall see, rabid criticism of her work, she nevertheless persevered and created some of the most glowing examples of beauty, the human spirit, and feminine strength in art history. Yet, after her death in 1653, she drifted into obscurity.

Artemisia expert, Mary Garrard, notes that Artemisia "has suffered a scholarly neglect that is unthinkable for an artist of her caliber." Why is that? McBride zeros in on a major cause. Artemisia was "disdained by contemporary critical opinion, recognized as having genius, yet seen as monstrous because she was a woman exercising a creative talent thought to be exclusively male." Artemisia further challenged the status quo by featuring strong, passionate female subjects. Gender based prejudice aside, living in a time of El Greco, Rubens, Caravaggio, Velasquez, and Rembrandt is challenging for any artist's status and posterity.

Moreover, in a mere century, the art world would explode with changes wrought by the likes of David, Goya, and, in the centuries to come, radical cataclysms such as impressionism and modernism. All of the aforementioned represent more a rationale than a good reason. Art and history provide meager examples of talent and heroics of Artemesia's magnitude. That brush and courage of this magnitude were evidenced in the hand and heart of a woman, makes the story too important to forget.

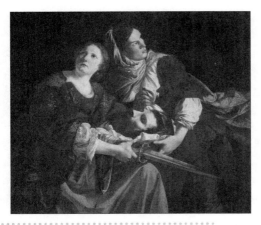

GENTILESCHI, *Judith and Her Maidservant with the Head of Holofernes,* 1613, Oil on canvas

Today

The enduring legacy of our wealth as a people is in the canvases of our painters . . .

— John Bademus

If we are to flourish tomorrow, the arts must flourish today.

— Michael Napoliello

Sixty-seven

Is painting dead? Well, there have been pronouncements (starting around Louis Daguerre's discovery of photography in 1839). There have been attempted assassinations (by the Dadaists and many since). There have been death certificates issued (from multimedia artists such as Bruce Nauman and celebrities such as Andy Warhol). Deadly blows from Nam June Paik. Grave dancing by performance artists. Real and figurative suicides in the 1980s.

In the '90s, visitors to major exhibitions (such as the Venice Biennale) found painting missing-in-action. And today's headlines and success of artists such as Cindy Sherman (photographer), Damien Hirst (exotic installations—his animal dissections in acrylic cross-sections are intoxicating and worth millions), Bill Viola (video artist), and Mathew Barney (film), lead one to believe that the coffin is finally in the ground. In truth, it would be difficult to calculate how many times

painting has been pronounced dead. Yet, just as we are sure that there is no breath left, the patient comes roaring back to life! Current evidence comes from the most popular museum shows (superstar painters like Picasso and Matisse), stellar auction prices, and renewed appreciation for mid-century masters (e.g., Pollock, Rothko, Johns, Diebenkorn) and the inevitable ascension of contemporary masters such as Ed Moses. And then, there is the amazing emerging painters, some you may know such as: Laura Owens (fun, primitive, and Zen-like watercolors and acrylics); Sarah Morris (household paint transformed into geometric utopias); and John Currin (whose amazing canvases can at once be mistaken for Renaissance masterpieces and boardwalk caricature). And there are names you will soon hear: London-based oil painters, Glenn Brown and Peter Doig; Takashi Murakami and Yoshitomo Nara from Tokyo; some friends of mine out of Los Angeles, Roger Herman, Andy Moses, and many, many more.

Painting, it would seem, is very resilient. Some would say that painting in modern times, like fashion, has a rise-fall-rise dynamic. But painting (unlike polyester suits), has never really gone out of fashion. Even in unpopular times, talented artists gravitate to the corporeal challenge inherent in the medium. I also believe that painting draws lifeblood from the pace of our times. The faster pace (of travel, communication, manufacturing, etc.) makes the timeless, contemplative nature of painting a potent and unique source of insight and sensation.

There is also the ageless and inexorable human attraction to a

ANDY MOSES, *Reverberation of the Stone,* 1995, Acrylic on canvas

great picture. Still, it is true that in today's art world, the focus and fame goes to new mediums and concepts. So, whither goes painting? As singer/poet Jim Morrison said, "The future's uncertain, the end is always near." I say: Painting is dead. Long live painting!

Sixty-eight

One of the most challenging art problems of our time revolves around restoration. Many of history's most important works are slowly, but surely, dying. On the other hand, cleaning can damage a master-piece irreparably. Ancient colors can only be guessed at. Chemical and material processes can never be exactly duplicated. Should we let a work age gracefully or try to reveal its former glory for present and future generations? I don't know.

The restoration of Michelangelo's Sistine Chapel executed in the 1990s inspires me in favor of professional restoration when done with love and great skill. Check out Carlo Pietrangeli's book on the subject.

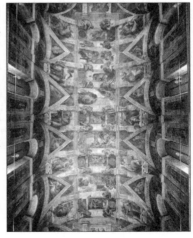

MICHELANGELO, General View of the Sistine Ceiling, 1512, Fresco

Sixty-nine

When will the art world appreciate women artist with equal respect as their male counterparts' Unfortunately, I don't know. There continues to be a socioeconomic bias (similar to other busi nesses where women have struggled for equa acceptance, pay, etc.). Perhaps even more damag ing is the art history bias (noted succinctly in *Ar History after Modernism*, by Hans Belting). Simply stated, the framework for art history was devel oped at a time when society was Euro/Male centric. Since this framework continues to pre dominate theoretical and popular perspective, i continues to be difficult for women artists to ge their time in the sun. Any general review of ar history parallels the history of men (white men to put a finer point on it).

Since, as Belting says, frameworks create thei own dangerous currents, it is important for a true art lover to swim against the tide. If you are no reading about female artists—seeing their work ir

museums, etc.—do not be fooled. It is out there. Perhaps in exhibition spaces, in studious, on the streets, and elsewhere. A few modern-day names of note that have broken through are: Lee Bontecou, Louise Bourgeois, Mary Cassatt, Judy Chicago, Karen Finley, Helen Frankenthaler, Ann Hamilton, Barbara Hepworth, Frida Kahlo, Hung Liu, Joan Mitchell, Louise Nevelson, and Georgia O'Keefe. Great work! Great struggle! (Alas, what is said here is also true for minority and global artists.).

Seventy

What are the prevalent artistic subjects today? (This is much more difficult to say now than it was in the past.) For nearly the entire history of art, religion and noble portraits were dominant themes.

In the last 100 years, artists embraced the subject of their inner perspective of the world (as evidenced in the popular works of impressionism and cubism.) Today, personal biography and psychology, urban life, politics, consumerism, race and time are important subjects.

Artists now have great freedom to choose their subjects. The study of how artists choose their subjects has been overlooked. This is unfortunate. The freedom (or lack thereof), of subject/expression in a given age will parallel that age's realities regarding politics, social order, education, human rights, religion, philosophy and more—in sum, the mechanisms of civilization.

Seventy-one

We live in a period when an artist can become super rich in his/her lifetime. This is historically unique—why? Standard rationale point to sociopolitical realities. Up until the middle of the eighteenth century (more or less) artists were of a class akin to high-level household or civil servants. But in the next 150 years or so, as free traders, it has only been in the last few years that successful living artists have flourished (though rarely) on the levels of their counterparts in business and entertainment.

Economic factors must be considered, also—specifically, supply and demand. Up until the mid-twentieth century, consumer demand was focused on a limited supply of historic European masterpieces (by deceased artists.) Then, along came an artist named Pablo Picasso—and, what I like to call, the Picasso Effect. Picasso's early works sold modestly—a few thousand francs, if he was lucky, for a year's output.

But Picasso was not only blessed with an abun
dance of talent and energy. He benefited greatl
by being discovered by independent and darin
collectors such as the legendary Pegg
Guggenheim in New York, and the Stein sibling
in Paris, as well as an ingenious and hard-workin
dealer, Daniel-Henry Khanweiler. And then, ther
was the massive exposure at exhibitions outsid
of the traditional museum network—the likes o
which the world had never experienced.

With this confluence of vision, skill, passion, an
exposure, wealthy collectors began to develop
taste for living artists—who in turn, created a lim
ited number of exciting works to increase thei
appetite. As Picasso continued to paint great works
his supporters worked their magic. For the firs
time, the world was aware it was in the presence o
living history, and demand went through the roof

While the scope and excellence of Picasso's worl
fell some in his last years, the prices of his work

ose to unheard of heights. Picasso enjoyed the ame of a Hollywood star and the riches of a busiuess tycoon. Since Picasso, who died in 1973, the dea of the "next Picasso" has—especially in good conomic times—made collectors extremely intersted in contemporary art—and generous to the rtists they believe will become legends. No one vants to miss the chance to discover (and profit rom) the next great artist. This is the Picasso Effect, which is not necessarily a good or bad thing.

While many artists are living more comfortably nd are indeed well off, many are crushed under n onslaught of premature interest and success. When their promise is (even slightly) unfulfilled, he rug is pulled out from under them—often eaving them worse off than if they were left lone to create and mature. (For a twisted look at he tragic comedy that is today's fortune-strewn rt world, watch the movie *Basquiat*, directed by ontemporary painter Julian Schnabel.)

Back to the original question: Why now? I don't know. But one thing is certain, the Picasso Effect will have a profound impact on the future history of art. Stay tuned.

Seventy-two

Outsider Art: misunderstood treasure or trend *du jour*? Hard to say, but there is a tasty debate currently spinning around the status of this potent and folksy art form (a debate, ironically, in which outsider artists themselves seem to have little interest.) Okay, the term "outsider" itself might be a concept created by art power brokers to seprate the mainstream from the fringe; but at the concept's core are the artists who "neither trained in art nor are making their works to sell them" (*ArtLex* online) but, rather, seem more interested in creating and communicating than in rhetoric.

Whether one thinks of isolated geniuses (like undeniable nineteenth century master Henri Rousseau . . . famous/tragic wunderkind Jean-Michel Basquiat . . . amazing but lesser known contemporary Sylvia Levine) or the back road, prison, and asylum artists from whom the bulk of this raw and visionary work comes (see the little known Anthony Petullo Collection for amazing

examples), it is my contention that these artis
are compelled to create—and it is we, as inte
ested parties (the viewer, the critic, tl
gallery/museum director) that struggle with tl
question of their status.

And struggle we do—with the politics of glob
art; with the prejudices of Euro/Western-centr
media; with self-serving exhibition promote
for/against outsiders; and, often, with passiona
fans who talk endlessly about how outsider a
either delights or repels them.

What is the well- intentioned art lover to do?
don't know. Though I can give you one reason wh
the question is more than just intellectual banter.
is important: STATUS=ACCESS. Regardless of tl
point-of-view of those doing the debating (ae
thetic, political, academic), the end result will affe
the opportunity to view and enjoy this work; ther
fore, I might suggest a few things we can consid
to help us make up our own minds.

When listening to criticism of outsider art, under-stand the agenda of the speaker. When viewing the work, appreciate the fact that it has overcome mainstream boundaries to find display space (ask how/why). Aesthetically, ponder what qualities are similar/different in relation to mainstream work (again, ask how and why). Finally, consider taxonomy's pros (it can focus our attention on remarkable details) and cons (it draws our atten-tion away from our own pure reactions or the work's fundamentals).

With these tactics in hand, can we draw absolute conclusions? Fortunately not. I say *fortunately* because in the end, that is not what creating and appreciating is all about. It is about the experi-ence—the joy of the

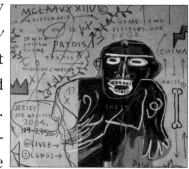

BASQUIAT, *All Coloured Cast (Part II)*, 1982, Acrylic and pencil on wood support

familiar and the shock of the new—in sum: th
wonder of discovery. Of this, outsider art has statu
in spades.

Seventy-three

Who are the power brokers of today's art world (and by this I mean players, not artists)? While money has traditionally been the objective measure of power, there is a major change taking place today. Critics and cultural institutions have lost some of their sway. At the dawn of a new century, we continue to witness the monumental impact of individual mega collector/philanthropists such as Charles Saatchi (vanguard supporter of new British art and major museum builder) and Eli Broad (voracious collector and $60 million dollar donor to the Los Angles County Museum of Art). Nearly equal gravity is felt from commercial super-galleries such as Gogosian, Marlborough, and the international auction houses. For the most part, these are the pillars that support the stage upon which the scene is played.

This is not to say that influence is limited to buyers and sellers. In fact, I would argue that the 2000s will be remembered for the ascension of

the independent curator. More and more, major collectors, museums, and exhibition organizers are hiring and handing over creative duties to bright, politically savvy, and passionately independent curators. Exhibition spaces and artists today believe that an association with the right curator is just as important as their associations with dealers and collectors.

Critics, cultural institutions, and the media consider this new breed today's key trend setters—their attraction not unlike that of celebrities. Perhaps it all got started with curator Harald Szeemann's popular and well- publicized (though some would say artistically disappointing) association with the Venice Biennale (1999 and 2001). There is also Dan Cameron, an important young mover-shaker who manages to hold influence as a senior staff curator at a significant institution—New Museum of Contemporary Art in New York—and a well-traveled independent. Rosa

Martinez has done trend setting shows every-where from Barcelona to Nepal with stops in Venice, Italy, and Santa Fe, New Mexico, along the way.

Michael Duncan's shows at the Otis College of Art and Design in Los Angeles and the Pasadena Museum of California Art have brought much attention to regional art.

Local rising star (local to me that is) Eve Wood—a key name to watch for—is a poet, critic, artist, and talented show organizer. In the same vein is Tyler Stalling of the Laguna Beach Museum of Art.

Of course, the power-curator phenomenon has its pros and cons. Closer to the artists (in practice and sensibility), these curators can often connect the public to the best of the avant-garde in a way that large institutions and philanthropists have been unable to do. Moreover, their ability to spot trends and create revealing thematic shows has proved uncanny. On the other hand, many artists feel that

this is just another marketplace manifestation—exclusively shaping the careers of "favored" artists and capriciously promoting pet causes.

Regardless of one's stance, today's major curators have joined the powerful ranks of big money, big gallery, big media. Where lays the true generalship? It's difficult to say. It is perhaps more accurate to think of interconnectedness. As I have often said in this book, there are many that pilot a work of art's journey from conception to exhibition. Understanding the players and the journey can help us see things (as Blake said) as they truly are.

Seventy-four

Should art dealers/galleries influence artists' output based on prevailing consumer tastes? Our gut reactions scream *no*. And yet, many who know better, including myself, are tempted to do otherwise. An artist friend of mine tells this anecdotal story: His medium-sized landscape paintings were selling well. His gallery was insistent he continue along this course. On one hand, he felt his work was losing its edge. On the other, the gallery was happy and making tons of money. The economic argument reads: Art is a business with required overhead and profit—serve the market. The aesthete argument reads: The artist's inspiration is the only consideration. Yes, there have been fantastic intersections of opinionated dealers and artists (Picasso and Pollock, and their respective dealers are classic examples). There have been many more disasters. Since the 1970s, especially when one considers performance art, land art, time art, etc., there has been a ground swell of

artists ostensibly rebelling against commercialism—in short, their work is purposely un-sellable.

A center position might be to approach art in the same manner as any design-based luxury item—its beauty and limited availability are what make it special. But the art world is not one of compromise and middle grounds. It is a tug of war between art and business—mainly because to what ends art should be produced is an unanswered philosophical question. Since a work of art is a concrete example of an artist's philosophy as well as skill, it is a question well worth exploring.

Seventy-five

Will "social" art, currently on the wane, make a comeback? The causes of its decline lead one to believe not. Yet, recent exhibitions of emerging artists feature a few talents with incredible sociopolitical sensibilities. Social art has a rich and important history. Major artists like David, Goya, Picasso, Rivera, Kiefer, and Kruger are just a few that have created profound expressions regarding war, poverty, human rights, and materialism.

An anecdotal survey of today's art witnesses a more personal (some would say self-indulgent), often profound, inner vision. Where the work edges on political, it is more a cultural commentary than the type of concentrated statement that can be found in the great political works of Picasso (like *Guernica*) or Rivera (i.e., *The Arsenal*). There are a number of factors contributing to social art's decline. Writer/curator Carolee Thea points to a common one: "backlash against social revolutions—the dirty stuff of the 1970s." But there are deeper roots.

Technology is one. Put simply, we have other ways to express and get our opinions.

It is hard to imagine, but as recently as Rivera's times (he died in 1957), television and telephones were a luxury. Information was costly and controlled by the elite. Today, technology's impact has enabled print and broadcast media, from the radio to the Internet, to provide widespread and nearly unlimited opinion—at light speed!

Another less prevalent reason is specialized study. From the time of the early academies up until the twentieth century, arts' education included some level of social study. In recent times, the focus has been on art theory and technique. The "art view" replaced the world view.

One final comment: We may simply be in a phase in art's evolution where artists are exploring and expressing their personal beings. But the art world, like the real world, is never static. The millennium dawned with explosions of ethnic and

religious strife, terrorism, and economic inequality. Artists have responded. One of the first pictures I saw after the September 11th tragedy was a monumental oil painting by a young artist named Ron Pastucha, who lived and worked in New York for a time. The picture featured a Baroque rendition of a freshly shorn Sampson in front of the modern New York City skyline. "I think it captures a city's sense of loss and hopefully serves as a reminder," he told me.

The work of German artist Jorg Immendorff studies/inspires the role of the contemporary activist. Born in Iran, New York photographer Shirin Neshat's brave work fights for all oppressed women. Londoners Jake and Dinos Chapman create powerful, antiwar mixed media presentations. Japanese born artist Jonathan Meese's work can rightly be called a political myth buster. American photo-activist Martha Rosler takes on the madness of "first world" culture wherever she finds it.

There are also groups like the Guerilla Girls and Group Materials keeping the spirit alive. Even Laura Owens, known for Zen-like paintings and a whimsical sense of humor, has (as noted by Malik Gaines) recently painted war protestors into her landscapes.

Though small in numbers (and by no means a movement), these brave and talented individuals are facing our times and expressing themselves in the best tradition of social commentary in art. Is this a "comeback?" We shall see. But where there is a spark . . .

Seventy-six

What is the paint type of choice today? Historically, artists' choices were limited. Today, they can go mad talking about paint. Author/educator Frances Homan reminds us that up until the 16th century, preparing paint was a costly and painstaking process. Hand wrought pigment was mixed with some unpleasant medium, like egg or animal skin glue.

Things changed a bit around 1550 with the advent of oil paint. But improvements came slowly. In the late 1800s, watercolor paints came into use along with the advent of manufactured pigments. Shortly after, like a sudden avalanche, came the collapsible metal paint tube—invented in 1841 by American born painter John G. Rand. This provided painters economy and flexibility heretofore unknown. The madness begins with an explosion of cheap color.

In the mid-twentieth century, notes Homan, artists like Picasso and Pollock where experimenting with

mass produced, bright, versatile acrylic and enamel paint—originally produced for commercial use. Their vanguard spirits may have encouraged geniuses of color creation, like Yves Klein and Frank Stella. Their passionate innovation led us to an era my associate, Nancy Silverman-Miles, calls the "Art Of Paint."

Artists today are obsessed with the development of the medium. Not only are they embracing older techniques, such as tempera and watercolor, and continuing to find fresh ways to dazzle with acrylics and enamels, but they are creating and discovering their own, individual processes. Some of today's best will amaze you. Artist/educator Mathew Thomas is doing unique paintings with the ancient encaustic technique (mixing resin with wax and pigment).

Andy Moses creates proprietary blends of luminescent paint incorporating industrial automobile enamels. (Don't ask him for the formula—if he tells

you, he has to kill you.) Los Angeles based artist Joshua Elias tells me he mixes minerals and oil and bakes them in the sun (at random times) to create "once and only" colors of paint. Another Californian, Monique van Genderen, creates colorful magic (in a series she calls "Fake Paintings") with applied vinyl films. Brazilian born Vik Muniz teases and delights us with the possibility of chocolate syrup, dust, and chemicals.

Digital artists are looking at the unlimited color output realities from the intersection of art and computer technology. One of my favorite paint explorers is Jennifer Wolf. It is not enough that she makes her own pigments. Recent work features pigment she personally gathered from Paleolithic cave sites in Southern France and treacherous canyons along the California coast. She risks her life for the right paint. Do we dare ask what *the* paint of choice is? Suffice it to say that today's palette is a flurry of evolution. What a colorful time we live in.

Seventy-seven

Lately, we've been hearing much ado about the "Basels." For more than three decades, Art Basel in Switzerland and its recently launched sister event, Miami Basel, have been billed "the most important annual art shows worldwide." Is this right? Let's imagine we are talking about it while sipping martinis at the lobby bar of the Delano Hotel in Miami. Okay? First, we need to define *most important*. It is certainly big. Annually, 170+ international galleries and approximately 1,000 artists are showcased for over 100,000 show goers. Breathtaking amounts of money (millions upon millions of dollars) are spent on modern master-works and emerging talents (not to mention the cash spent on designer hotels, expensive morsels, and nonstop cocktails that keep the VIP parties going). In all, the "Basels" deliver the pomp, celebrity, and publicity you would expect from a creative and well moneyed mega event.

Its popularity is another reason for its impor-
tance. The faithful and new converts make their
way to Switzerland and Florida each year—so
much so, in fact, that it's becoming a pilgrimage,
which certainly is a good thing for art overall. The
fact that the events are so professionally run
should not be underestimated when calculating
their value. Artists and guests are treated with
respect and style. The shows are a treat. They are
something to get excited about; they are good
business. This, of course, does not mean, as insid-
ers would have you believe, that these shows are
indicative of what is happening and important in
art today. At its heart, Basel is an art fair—a mar-
ketplace. A place to see available works from the
last seventy-five years, and popular new art. In
fact, because of the costs involved (for galleries
and collectors), Basel often comes off as more of a
trade show than a cutting-edge event.

Shows with lesser public relations and access, Documenta and Venice, respectively, give a truer take on the current world of art. There you may stumble on the next Picasso or a surprising local phenomenon. But these shows can be somewhat esoteric and overwhelming. For this reason, and the fact that so many of the other shows are so disappointing, Basel does stand out. However, I suggest you save your money and visit your local museums, galleries, and artists' studios. But, hey, on the other hand, the Swiss are a fine people, and Florida is mighty sunny. Check it out for yourself and let me know what you think.

Seventy-eight

Are we at the end of the road for marble? A thorough review of sculpture chosen for Taschen's Art Now (survey of 137 important young artists) and other such publications leads us to believe that, yes, marble's reign is over. My recent visits to major exhibitions provides further evidence. Carving from stone is one of the most ancient of art forms. Marble, in the right hands, is malleable and beautiful. But quality marble is relatively rare and difficult to mine. This expense is one of the reasons for its decline in use.

Historically, patrons with Pope-like wealth and power (like the Pope, for example) could concentrate money and logistics on providing ample marble for significant projects. In recent times, artists have become more or less entrepreneurs—and the cost of marble and the time- consuming sculpting process is a difficult path to financial success.

The use of marble is out of favor for aesthetic reasons as well. Artists have a fascination with cutting-edge materials. From metal casting (improving during the 1500s) to nineteenth and twentieth century inventions (like cardboard, concrete, neon light, Plexiglas and fiberglass, plastic, nylon, fiber optics, etc.), artists consistently embrace the new—conceptually, as well. Attempts to explore the existential pace of modern life lead artists to alternative approaches that allow them to transcend the static qualities of marble.

While marble "speaks" of the eternal, constructs with crushed cars (used in *Compression of a Car* by Cesar Baldaccini) and soil and tides (like *Spiral Jetty* by Robert Smithson), for example, communicate randomness and transience. I also believe that the existential zeitgeist of our times drives artists to seek strange and inventive ways to relate. For better or worse (mostly worse),

Duchamp presents urinals as sculpture (circa 1917). Jeff Koons puts Hoover brand vacuums on pedestals (circa 1981). Damien Hirst places dissected animals in formaldehyde "aquariums" (circa 1991) . . . not a trace of marble dust. Nevertheless, fine art schools continue to offer courses in stonework. Amateur artist groups are taking up hammer and chisel. Art fans crowd museums to gaze in wonder at marble masterpieces. Keep in mind, it was late nineteenth century powerhouse, Auguste Rodin, known for his raw and passionate figures in marble, that inspired seminal modern masters like Constantin Brancusi and Hans Arp—in many ways leading to the mavericks mentioned above.

Today, internationally established artists and local favorites, like Wollaston Award winner Marc Quinn, Great Britain's Helaine Blumenfeld, and Los Angeles based artist, Mike Hill, respectively,

are keeping marble fresh. Time will tell if the timelessness of marble will once again have its day in the sun.

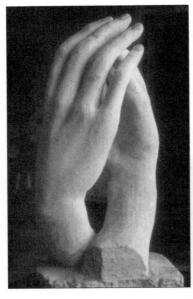

AUGUSTE RODIN, *The Cathedral,* 1908, Marble; HANS ARP, *Female form,* 1953, Marble

Seventy-nine

How does a curator go about selecting art? Of late, the curator's role has changed greatly. The term *curator* was originally coined to denote "care-taker"—one who cares for a collection. Today, curators are the driving force of the art world. They are researcher, exhibition designer and promoter, tastemaker, and—to the consternation of many artists—institutional gatekeeper. Inasmuch, the question of how a curator selects art for display is an extremely important one. Yet, despite an unprecedented rise in graduate level curatorial studies and museum programs, the curator's practice remains one of personal preferences and politics. With that in mind, the best way to approach the question of "selection" is to ask the curators themselves. When you do, a general checklist arises. Topping the list are (1) looking (most review all the key art publications and thousands of artists' slides each year) and (2) traveling (to studios all over the world). Lots of

eyestrain and air miles, they say, enables them to get a better sense of the importance and quality of the work under consideration. Most agree that it is also wise to consult top collectors. The risk here is that a collector is often influenced by many "non-art" factors (such as fads, finances, friends, etc.). But collectors put their money and emotions behind their choices and, living close to their treasures, can provide interesting insights. Curators also ask artists they admire.

Artists know the best artists, no question. Of course, there is always the temptation to promote friends—adding insulation to an already insular world. Many curators have told me that they are not so much looking at particular works of art, but for a connection between works of art—an artistic or conceptual spark that flies when certain works come together. A theme, if you will. Other curators call on backgrounds in history and sociology to

help them spot powerful societal currents, or cross currents, in new work.

Curators, and the choices they make, stand at the intersection of fine art and the public—an incredibly powerful position. Yet, truth be told, there is little science or established protocol behind their decisions (aesthetic or otherwise). "Ultimately," as noted author and art critic Barry Schwabsky says, "it's their own view." When we experience a work of art, we are experiencing more than just the artist's vision. We are dancing through a gallery to a curator's choreography. Asking, "How they go about selecting," reveals a few of their more subtle steps.

Eighty

Today, we live in a celebrity obsessed society—and perhaps it is true that the worship of movie stars, professional athletes, pop singers, TV ministers, soap opera stars, and nobodies that have become "somebodies" on reality shows, is a plague destroying the world like *The Blob* in the 1950s horror flick.

The way critics tell it, the problem inherent in a celebrity obsessed culture is the risk of becoming a civilization of "second-handers"—abandoning the innovative for the notorious, the talented for the famous, personal experience for gossip.

Today's artists are putting up a fight. How is this changing the face of art? Ask Jonathan Horowitz. He interrupts Mary Tyler Moore and Molly Ringwald videos with his own personal messages (such as "I think I have AIDS."). By deconstructing—what he calls, "television time"—the Hollywood illusion is shattered. Look at Damien Hirst's twenty-foot painted bronze figure, *Hymn*. Hero? Famous

personage? Idol? Hardly. It is a nameless, sterile, anatomical front section (right out of Gray's Anatomy). Similarly, John Isaac's sculpture of a colossal turd reminds us that, in the end (or should I say, out of the end), we are all the same.

Robert Longo places cliché images of business-men and secretaries in Cecil B. DeMille-esque poses—strange and ridiculous. Laura Owens retreats into her dreams. Peter Pommerer replaces Hollywood utopia with his own psycho-spiritual installations. Richard Phillips creates paradoxical paintings of fashion models and famous people that are at once homage and effigy. Then there are Cindy Craig's richly detailed watercolors of the Meat section of Costco, of all things! No chance of Britney Spears showing up in these paintings; but, in their prismatic desperation, they are beautiful. There are many other exam-ples. All are producing an antidote for a *People* magazine planet.

From it all, I cannot pinpoint an emerging aesthetic—though there is a rally banner. A quest, if you will, for artistic mastery over the empty grail of fame. Call the paparazzi.

Eighty-one

There has been a spate of "celebrity painters" emerging over the past few years. On the tip of this iceberg are Joni Mitchell, David Bowie, Martin Mull, and (just last night at the Edgemar Center for the Arts in Santa Monica) Sandra Stephenson (1950s' femme fatale, Sandra Knight). Can these efforts be taken seriously? They are received with the popular reverence rewarded celebrity, and the whispered cynicism placed on anyone daring to step out of their avowed specialty. (The paparazzi were out en masse for Sandra's star-studded opening—but, hey, can an actress paint?) The paradox is that Mitchell, et. all., because of their fame, receive public and critical attention most artists only dream of; yet, because of this fame, they will find it difficult to be taken seriously.

It is important to note that all arts have the same roots (inspiration, imagination, visualization, realization) and the same fundamentals. Thus,

there is no de facto reason a singer, actor, etc., cannot be multitalented. Technically, on the other hand, music, comedy, and acting could not be different from painting.

Celebrities, like those mentioned above, have given over much of their energy and focus to their craft, perhaps never developing the dexterity of hand and keenness of eye it takes to create visually challenging fine art. It is difficult to resist the power of celebrity. But in fairness (to ourselves and to the artists), we must approach the work with the same open and critical minds we bring to any artist's work. I believe that the above artists wouldn't have it any other way. That is the essence of their credibility.

Eighty-two

Is New York City still the center of the art gallery world? A combination of wealthy and daring dealers at the turn-of-the-century, massive immigration of superbly talented artists during the great [horrible] wars, and the emergence of America's wild artistic genius after WWII, planted New York firmly at the top of the art gallery world. It has remained there, unassailable, through 1990.

Quantum leaps, such as the founding of the Ferus gallery in Los Angeles in 1957 and the Pompidou Center in Paris in 1977 (rekindling a passion for contemporary arts in France) never gained the critical mass necessary to stop the New York juggernaut. But even after years of big money on 57th Street and excitement "downtown" New York was unprepared for the explosive art market "bubble" of the 1980s. As we know, this market crashed, leaving a wide swath of shuttered galleries, shaken dealers, and fleeing collectors.

There remains in New York an infrastructure (galleries, modern museums, collectors) unparalleled in the world. But the spirit of innovation and confidence has become diminished. Some would say soulless, at best, pressured. Not surprisingly, other locales have emerged to fill the void. London, rife with galleries and anchored by energetic young British artists, the collections/philanthropy of Charles Saatchi, and a prolific art press, is, as they say, hot. Southern California is finally starting to build an "art business" worthy of its talented home-grown artists (modesty and ethics preclude me from plugging my own contemporary gallery: Gallery C in Hermosa Beach—oops!). Paris has a sturdy and time-tested infrastructure ripe for revolution. And let's not forget Tokyo, where a fabulous new contemporary art museum (the Mori), the worldwide breakthrough of Japanese artists, and a revitalized (sort of) economy, bode well for the future gallery scene.

Like many subjects in the art world today, a clear picture is illusive. There really is no center, but a network of loosely joined angles. A web of wonders. Frustrating. Fascinating. Grab your airline miles and go forth—you never know when you might find yourself in the center of the world!

Eighty-three

Mannerism, Neo-Classicism, Realism, Impressionism, Post-Impressionism, Pointillism, Symbolism, Fauvism, Expressionism, Cubism, Futurism, Surrealism, Abstract Expressionism, Minimalism, Neo-Expressionism, Post-Modernism—this barely covers just the last few centuries of art "isms." Why are there no dominant isms today? Unknown—but there are clues. Primarily, isms grow out of a geographical congregation of artists and ideas (i.e., impressionism is inextricably linked to France).

Today, there is no dominant art world center. The result is kaleidoscopic. Isms are also traditionally idea based (surrealism's focus on subconscious analysis, for example.) Today's artists tend to be medium driven (performance, textile, earth, paint, digital, etc.). It may also be that after 500 years, the need/desire to follow a single ism is on the wane. Prominent Los Angeles based painter Ed Moses embodies this adventurous spirit—as noted by

critic Peter Frank: "Moses . . . has exercised his sensibility on a surprisingly wide range of given isms, demonstrating the multitude of possibilities"

Ultimately, isms are language constructs, made up by artists, critics, academicians, and the like. Perhaps no one has invented one lately clever enough to stick. Curator Jeffrey Deitch coined a term—Post-Humanism—for one of his contemporary exhibitions (based on new technologies' impact on our bodies and our lives)—but it has not caught on (sorry, Jeff.) Being ism-free can be a drawback.

It becomes difficult for art fans, collectors, and media to know where to look and for what to look. But, I personally feel that this is an exciting time. No-ism may mean that we have entered a golden age of hyper-eclecticism (oops, did I just use an ism?). Or, there may be a great new ism right around the corner.

Eighty-four

When Rene Magritte painted the words *Ceci n'est pas une pipe* (This is not a pipe) in oil on canvas in 1928, he had no idea that his little experiment combining words and images would become an obsession in the next millennium. Artists today are creating sculptures, designing installations, and filling canvases with bits and pieces of letters, words, poems, stories, advertisements, headlines, and quotes (their own and others').

Why this trend, you ask? This is the same question I have been posing to artists around the world. Their answers are as different as their work. For some, it is very basic: Words draw attention to ideas. For others, letters, words, etc. are simply forms—like a flag or a tree branch. Images and words combined can illustrate the tension between reality and our illusions of reality. There is also evidence that the integration of words into the visual arts is a reaction to the modern world—

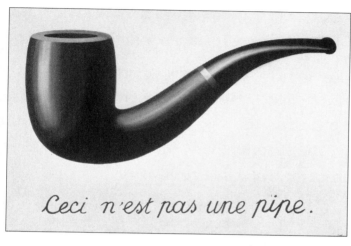

MAGRITTE, *Ceci n'est pas une pipe,* 1928, Oil on canvas; LORI PETTY, *That Ain't Even Your Hat,* 2003, Mixed Media on wood

where street signs, billboards, video monitors and the like seem to attack from every angle.

Many younger artists see words as weapons—theirs and the enemy's. Since many words have the power to prejudice, oppress, confuse, etc., visual artists have the opportunity, by usurping these powers, to impact the world in a positive way.

On a recent visit to artist Michael Arceda's studio in San Francisco, he showed me U.S. maps he made utilizing Spam (mmmm, Spam). The inspiration, he told me, was that Maps is Spam spelled backwards. That word, for him, said it all.

Eight-five

Is there a "hot" medium today? Marble and oil paint dominated art through the centuries. Video and performance were raging during the 1970s. When I was in school in the early '80s, shaped metals were the big thing. Later that decade, young art stars like Julian Schnabel and Jean-Michel Basquiat inspired the long-running popularity of acrylic paint (pioneered by moderns like Picasso) applied to canvas and found objects.

Digital processes were an emerging force by the end of the 1990s. Today, like so many aspects of art in the new millennium, experimentation seems to be the only trend. In a medium landscape that includes Tom Friedman's self-portrait carved in aspirin, Damien Hirst's animal dissections, and Takashi Murakami's vinyl balloons, it is indeed difficult to spot a pattern of selection.

One of the few certainties we find is the prevalence of "mixed media." Though it has not been explicitly stated, if there is a consensus among

artists, it seems to be: Anything *can* (or everything *must*) be used to create art. Of course, as one wanders through major exhibitions, the abundance of traditional paintings captures the eye. But this is more a function of the four-wall-format than a statement of what's happening in art today. In mysterious enclaves, on the ceilings, below the floors, and around corners, we find a whole new world of materials and objects—old and new in exotic combinations. This era is perhaps inspired by Ernesto Neto (himself known for using everything from stockings to Styrofoam in his installations) when he indicates that his job is the exploration of the sensuality of his materials.

Eighty-six

A major new trend is the emergence of pre-planned, public/private artist communities (wherein artists live, work, and exhibit in the same development). A proposal being examined in Ventura, California, is illustrative: Ventura is considering providing land and funds for the construction of integrated artist loft, public exhibition, and park spaces. This project, the city believes, will attract talented artists, tourists, and art loving residents. How will this change the art world? From a business standpoint, places that have embraced the trend, like Venice and Laguna Beach, are seeing a mini-boom in development investment.

The risks are many. However, the rewards, the developers and cities hope, are profits from under-utilized zones, increased tax revenues, and improved quality of life. As with any venture, time will tell if these hopes are to be realized. Of course, quality space being made available to artists is never a bad thing. Communal developments will

engender creative collaboration among artists. Convenient, attractive exhibition spaces will encourage public appreciation of the arts. The success of these plans will lead to efficient national/international proliferation. Museums and galleries will need to adapt to new realities since their exclusive (some would say elitist) access to the public and artists will be challenged. These changes will be exciting.

Ironically, the success of the planned art community could have an adverse effect on the cities and the artists themselves. By "guiding" artists to particular areas, cities may be curtailing an important evolutionary force—artists as neighborhood vanguards. Furthermore, competition for these high profile spaces may make participation by the most cutting-edge artists unaffordable.

Finally, public intrusion can be, at best, a welcome source of patronage for the artists; at worst

a major distraction. One thing is certain, this is an important experiment that may change the course of art history. If you are ever in town, check it out.

Eighty-seven

While contemporary art publications are documenting the rise of global art, there is almost no mention of contemporary Russian artists. (The prestigious *Art Newspaper* does not even include a Russian city in their annual "city guide"—an important review of today's art centers.) Why is that? Political realities come quickly to mind. Past generations (including masters El Lissitzky, Kasimir Malevich, and Wassily Kandinsky), were forced to emigrate, scattering their seeds far from home. Though less oppressive, Russia today remains rife with political and economic turmoil—difficult ground upon which to build and promote a thriving art scene. But other countries, notably India and China (discussed elsewhere in this book), face similar problems and find their artists gaining profile on the world stage. We must look deeper.

I have noticed that after major political upheavals (and there was none greater than the fall of the

Soviet Union), countries experience a time of artistic silence. This apparent inactivity is really a time of gestation—underground, artists are hard at work. Spain, after the fall of Franco; Iraq today; and, inevitably Cuba, are all examples.

There is also the issue of cultural heritage. With a few exceptions, most notably Kandinsky, and a few of the Suprematists, Russian art is inspired by folk tradition or political realities. This tends to create furiously wonderful music, but conventional painting and sculpture. Yet, on the borders of mother Russia and the international art scene, there stirs innovative and talented young Russian artists (such as Vladimir Dubossarsky, Alexander Vinogradov, Andrej Vystropov, Ida Ahelznova—and, of course, the infamous dog-man, Oleg Kulik.) There are many others just out of sight.

Perhaps, out of Russia's history of passionate revolution, experimental film, and amazing music, we will find the next generation of artists on the

cutting-edge of multimedia. Perhaps, too, there will be an evolution of folkways that change the fine art world forever. Or, then, perhaps there will be an uprising we can't even imagine.

Eighty-eight

These days the world is transfixed with news of China's political and economic fortunes—but nary a word is spoken of her contemporary art scene. What's with that? One thing I can say for certain, is that it is surprising. Dynamic times inspire exciting artistic achievements. Moreover, art can be a leading indicator (to borrow an economic term) in a time of great change. Yet, contemporary Chinese art remains "off the radar."

One reason may be centuries of government intolerance of avant-garde work. Style has been consistently encouraged over daring, tradition over experimentation (China's Biennale 2000 was the first time that avant-garde art was ever allowed in a national art gallery). Yet, it is daring and experimentation that capture the world's attention. Another reason, according to art critic Robin Suri, is the Chinese art world's predominant trend of promoting "established (artists), those who have managed to capture attention . . . by embracing

European or North American practices in their art." Emerging artists have been neglected.

Lastly, contemporary Chinese artists have continually featured figurative and familiar subject matter. Similar to Latino and Italian art, the work is sexy, colorful, humorous, and strangely familiar. Nevertheless, the art world at large is interested in more radical ambitions.

But, just as China has caught the attention of the political and financial worlds, the fortunes of Chinese artists may be about to change. Artists in Shanghai, Beijing, and Guangzhou (the core of China's art scene) are bravely embracing the cutting edge. Artist/activist groups, such as The Big Tail Elephant, are the first in China's history China is also home to an incredible depth of "new art" (non-painting) talent, such as Zhang Peili (in my opinion, the most important Chinese video artist) and installation artist Shue Jie Painters like Xie Qi and Craig Yu have blended

traditional Asian aesthetics, abstract expression-ism, and their own original genius to create some very futuristic looking work.

Chinese performance artists are starting that revolution all over again. Then there are "one-and-onlys" like eco-artist extraordinaire Cai Guo-Qiang. Prescient are these words from the *Business Standard*: "Contemporary art in China has now reached a stage where it's beginning to break barriers and go into bizarre experiments. In many ways, the transformation of the Chinese art landscape has been as dramatic as the physical transformation of the country itself. In fact, the two seem to influence each other. What we are witnessing in China today is an unprecedented cultural revolution" It may be about time for the world to have a look!

Eighty-nine

Why isn't contemporary UK painter George Shaw well known? Maybe the timing is not right. Maybe his most amazing work is yet to come. Or maybe he's just painting the wrong things. In the serendipitous art world, you can never tell. But, I would like to look at this last possibility. In a rare Shaw review, one supportive writer was compelled to say, "This is not the kind of art you learn in art school and build theories around." What are these strange images that keep this award-winning artist out of the hot exhibitions and collectors wringing their hands? Landscapes. Simple landscapes. Beautiful landscapes. Common places. An aging suburb on the edge of a bleak wood. A ramshackle garage. A blue collar hamlet in quiet dusk. A muddy path, spotted with greasy white puddles, drawing us beyond broken down fences and tract housing rooftops.

There is nothing trendy, outrageous, hip, or conceptual about these works—they are simply perfect. They capture, by combining muted colors, mood,

and detail in such precise balance, the soul of unimportant places—and in doing so, they make poetry out of a candle seen burning through a dirty window.

In another time and place, Shaw's name might be mentioned along with Rembrandt's—but the art world is different today; and artists are encouraged (by critics, galleries, fine arts programs) to eschew any sign of tradition. Shaw's pictures are not cool. They're just right.

\W, *Scenes from the Passion: Christmas Eve,* 1998, Humbrol enamel on ⋅rd; *Scenes from the Passion: Hometime,* 1999, Humbrol enamel on board

Trompe l'oeil is roaring back. Just this March, there are three important shows featuring 11 contemporary practitioners, including Gary Erbe, Jeanette Pasin Sloan, and Elena and Michel Gran. A popular Renaissance innovation, trompe l'oeil ("trick of the eye" realism) flourished until overshadowed by twentieth century innovations such as abstraction, photography, video, and multimedia. So why a comeback now? Sometimes, the world of art is funny. An old technique, long considered passé, is rediscovered by a talented young artist and becomes hot. A gallery decides to break with trends and put on an arcane retrospective; or, more likely, a daring designer or collector says "to hell with popular taste" and finds their own path. Auction prices start heating up for an overlooked genre. Unsung contemporary masters are "rediscovered" (in this case, the likes of the great Duane Hanson, Marilyn Levine, Richard Haas, and Kent Addison).

t is likely that all of the above, and/or some other erendipity, has led to trompe l'oeil's triumphant eturn. What I can say for sure is that it is a good hing. Trompe l'oeil represents painstaking craft in mass- produced world. It provides a sentimental nd startling view of reality in a time of bland uperficialities. It is a simple joy to behold in an ver more bleak world. Welcome back.

OHN FREDERICK PETO, *Rack Picture for William Malcolm Bunn,* 1882, Photograph; DUANE HANSON, *Old Couple on Bench,* 1994, Photograph

Ninety-one

I was planning to ask: Why don't more people know about Red Grooms? It frustrates me that this great American artist (b. 1937 in Nashville) is not more widely appreciated. But, ironically, I am going with: Is it okay to laugh when I look at Grooms' work? Admittedly, it is easy to see the humor in Grooms' unique "Rockwell on acid" paintings and sculptures. But Grooms is an important, internationally-exhibited, museum-collected artist; and we are not supposed to laugh when we look at important, internationally-exhibited, museum-collected art—are we?

Between the covers of art theory books—in art schools, at the openings of fine arts galleries, in the halls of major art museums—it would certainly seem not. Perhaps the goal therein is to promote the importance of art by always taking it "seriously." I will not argue with those who encourage artists and viewers to take a studied

approach. But, I believe, overlooking the role of humor in art, limits its gravity.

Grooms utilized the bittersweet humor that he found in mainstream conventions and human idiosyncrasies as an inspiration. The hyperbolic caricatures in his work force us to laugh at ourselves in order to see our common strengths and weaknesses. Suppressing this laughter limits the experience.

This can be said for many great artists through history—have another look at Bosch, self-portraits by Ducreux, selected works of Picasso, performances by Klein, and almost everything by Warhol. Without the chance to speak to the artists directly, I cannot say that laughter is an intended effect. Nor can I prescribe a course for incorporating laughter into art appreciation. But I am sure that humor is part of artistic genius. Next

time you are in a gallery and you feel like sneak
ing a laugh, go right ahead.

GROOMS, *Agricultural Building,* 1992, Sculpture (steel, brick and wood)

Ninety-two

There are, of course, fine artists focusing on religious subjects today. Ion Popei's beautiful reinterpretations of Christian altarpieces. The famous Buddhist works of Tang Lijian. The multi-faith wonders of Gurmi Lama. A few of Michael Fornadley's better paintings. The ever-celestial Alex Grey and Barbara Rizzo. The brave urban spirit of Kevin Knuckles. And the wonderfully blasphemous large oils of Ron Pastucha. But, overall, I agree with artist/author/gallerist James Lane when he says that religion in art has become "practically nonexistent." Strange. Religion was the primary artistic subject from about 200 A.D. until the late gothic (circa 1320), after which we witness a precipitous drop off.

According to art historian (and one of the most intelligent and straightforward people thinking about art today) James Elkins, this phenomenon was obvious to everyone, "yet hardly whispered about." While masters like Michelangelo and

Rubens kept the flame alight in the sixteenth and seventeenth centuries, by the nineteenth century serious religious art was a thing of the past. Why? Good question when you consider the ranks of the religious (and their fervor) are at an apex today. Most conjecture starts with the (modern) nineteenth century idea that all art is spiritual, so it doesn't need to be "about" spiritual subjects.

As poet Alfred de Vigny declared, in step with the romantic, revolutionary spirit of the times, "art is the modern spiritual belief." It is possible, though, that the real revolution started as far back as the Renaissance where artists, blessed with profound talent and relatively liberal patrons, created art that glorified their abilities and, as Elkins notes, "made viewers think more of the artist's skills than of the subject that was depicted." But it took more than fourteenth century chutzpah and nineteenth century romance to change the meaning of art. Science and technology, as they so often do, predicated a

change. For the religious, improved techniques for printing, casting, and ceramics afforded the opportunity to decorate temples and distribute icons without a reliance on large numbers of fine artists. For artists, breakthroughs in optics, psychology, chemistry, and philosophy drew art to nonreligious aims—such as Monet's experiments with light and Cézanne's radical views of nature.

Politics may have played an important role as well. On the heels of the French, the American and Russian revolutions codified the "separation of church and state." Artists agreed, with a twist: separation of church and art.

Finally, there is human nature. Things tend to go, without major upheavals, the way they are going. Stemming from recent history, this means that fine art is secular. I am not sure that any one or a combination of these ideas successfully explains art's abandonment of religious content. But these "whispers" can be put into two definitive

categories—Vigny's: All art is spiritual; or, the contrary. To further confuse the issue, let me suggest another possibility—a third category beyond "secular" and "non-secular." What is it? I don't know. Perhaps an evolution of the human mind/spirit. How to define it? Watch tomorrow's artists.

I leave you with a quote from twentieth century minimalist painter Barnett Newman: "What is the explanation of the seemingly insane drive of man to be painter and poet if it is not an act of defiance against man's fall and an assertion that he return to the Adam of the Garden of Eden?"

Ninety-three

Viewing the meteoric return of the human figure in art, one must think that the great experiment with abstraction is drawing to a close. Leading artists such as Francesco Clemente and Eric Fischl, the next wave (like Christian Vincent, Kim McCarty, and John Currin), and a stroll through major museums and art galleries, provides plenty of evidence. Is it possible that abstraction, last century's world-changing modality, has reached its climax? This question is a head-scratcher even for the mighty Hilton Kramer (see his article in the December 2002 issue of *The New Criterion*). Kramer sees the issue less as a shift in public taste but more as a withering of abstraction's power (after minimalism) to influence young artists. But he encourages us to look beyond today's painting and sculpture to find abstraction's legacy (i.e., installation, computer graphics, virtual art, music, etc.).

Renewed apperception for abstract artists such as Ellsworth Kelly and contemporary artists (such as

Sue Williams and Peter Lodato) provide evidence of abstraction's lingering spark. These developments aside, the figure has once again taken hold

It is important to keep in mind that figurative work has dominated art for nearly all of history. Yet, so great has been abstraction's bright spell over artists and the public during the last 100 years, it is difficult to think of today's work as anything but a radical new development.

Ninety-four

It is March 25 (2004), and my team at Gallery C is preparing for the opening of "LA Woman" featuring five fantastic (of course, I'm biased!) Los Angeles based contemporary artists: Lisa Adams, Meg Cranston, Jill Giegerich, Becky Guttin, and Kim McCarty.

I am happy to say that the show is drawing a great deal of public and media attention. In preparing the exhibition, I was asked an interesting question: "Is this feminist art?" While the curatorial statement notes new opportunities and continuing struggles that female artists face today, there is no fundamental feminist intent—it is simply painting and sculpture by formally accomplished artists. Yet the question sticks and expands—is the work of a female artist inherently feminist? My immediate answer is "no" when I consider the strictly defined program of feminist art pioneers such as Judy Chicago and Miriam Schapiro. Their art, and that of their contemporaries, bravely and

head-on, dealt with gender- based inequities in art and society.

Other avowed feminist artists, such as Carolee Schneemann and Hannah Wilke, "present their bodies as their art" and make strong social statements by defying prejudice and convention. Then there are groups such as the Guerrilla Girls, wherein their activism is their art (it is hard to misunderstand the point-of-view of artists that call themselves the "conscience of the art world" and claim one of the advantages of being a woman artist is: "Not having to choke on those big cigars or paint in Italian suits."). There are no such banners in the works of Adams, Cranston, Giegerich, Guttin, McCarty, and many other accomplished female artists.

In front of me I see whimsical installations, delicate watercolors, colorful abstract paintings, and architecturally profound sculptures. There is not a literal trace of feminist issues. And yet, there is

something special and different about this work. I think about the struggles these women had to face to get to this point, the freedom the work exhibits, the sensitivity. A personal depth I don't often see in their male counterparts.

I am beginning to think that, regardless of content, there is a bond to their radical sisters. In today's art world, gender issues have taken a backseat to other crises—so I fear a better answer to our question is not forthcoming. This is unfortunate because, I believe, this bond may be a solution to many of the world's problems.

Ninety-five

How many artists are there in the world? My best guess comes from averaging censuses from countries around the globe. Here we find that one-tenth of 1 percent of a given population will report their primary job is artist (painter, sculpture, fine artisan). One-tenth of 1 percent of the estimated global population of 6.4 billion is 64 million. This is not an improbable number; but, for a number of reasons, it is certainly inaccurate. Lack of data is one. Few countries have regular census; and, worldwide, definitions of "artist" vary. Many artists report only their primary income-generating occupation (e.g., teacher or writer.) Moreover, artists are notoriously "off the radar" (as students, wives, unemployed, or simply not reporting, etc.).

Finally, accurate censuses are infrequent and dates of census from one country to another rarely line up—so there is no way for us to know how many artists there are today. The question,

though, is important for a number of reasons, including: job growth estimates, educational planning, government and philanthropic endowments, etc.

My feeling, based on the vitality of the contemporary art world, is that the 64 million number is low. This is a good thing for the "health" of the arts. My contention should not, however, impart a false sense of security.

Art is an important cornerstone of civilization: Science, entertainment, history, fashion, education, museum, diplomacy, and countless other industries/institutions rely on fine artists. Yet, art is a rare calling and an uncertain path—swiftly, the artist population can decline. Allow me to stand high up on a soapbox to say that (with or without accurate numbers) high up on *any* nation's agenda should be support of the arts.

Ninety-six

The California Resale Royalty Act provides artists a share of the profits (approximately 5 percent), should their art be resold at any time. This California law is unique in the United States and most of the world. Is this well-intentioned law a good thing?

On the plus side, it enables artists to share in the (possible) future appreciation of their work. This can be significant relative to the original sale price. This law also affords artists the opportunity to more reasonably price their work today, since they will be "partners" in the future success of the work (they don't have to "hold out" for the highest price). Ultimately, the law recognizes that ownership of the object is transferred to the purchaser, but not usage rights—this is an arguably positive extension of copyright law. Pundits supporting this law argue that "in other creative fields, artists are able to benefit from continuing commercial use of their work (e.g., the sale of

published sheet music, public performance of their music, and sale of sound recordings, which incorporates their music.").

But, in these examples, the purchaser receives the benefits of the art free or by the token cost of a ticket. One could argue that buying a sculpture or painting is more akin to buying (in the case of music) the publication rights or the master tapes. While seemingly detrimental to the artist, this would "add value" to the work in question and possibly enable the artist to command higher prices initially for original work. Moreover, some California collectors are put off by this law, decreasing demand, which deflates prices. Also keep in mind that this law does not allow purchasers to recoup losses anticipated by deprecation of the value of the work—a contractual inequity.

From a legal/philosophical standpoint, is a work of two/three-dimensional art different from any

other product? If no, then why should the purchaser be burdened with resale restrictions and bureaucracy? The law is too young and its application too limited to provide a clear picture of its positive or negative impact. But there is a worldwide trend toward stricter copyright law and commerce legislation. At some point in the near future, artists and collectors will want to understand both sides of the issue and take an educated stance.

Ninety-seven

Is the small art museum in America really, as the *Wall Street Journal*'s Lee Rosenbaum recently stated, an "endangered species"? It looks that way. This is a shame. Small (also known as boutique or "jewel box") museums provide the public an intimate, thematic art experience no mega-museum can. Their popularity is well established throughout Europe, in the likes of the Picasso Museum (Paris), The Van Gogh (Amsterdam), the Michelangelo House (Florence), and many others. Their architecture usually provides a space for art that is, according to Rosenbaum, "homey rather than overbearing." Rosenbaum continues: "This explains the great affection visitors feel for the Frick Collection in New York, Gardner Museum in Boston, Clark Art Institute in Williamstown, Mass."

The same can be said for my favorites in California: the Di Rosa Collection, founded by Rene Di Rosa in Napa Valley; the Museum of Latin American Art in Long Beach; and the

Pasadena Museum of California Art (PMCA), founded by Robert and Arlene Oltman, and directed by Wesley Jessup (formerly of the Guggenheim). I agree with Rosenbaum when she notes that "the dominance of today's attendance-driven encyclopedic museums has endangered the . . . jewel box."

Many simply do not have the budget and marketing clout to attract customers and gain member support. Others suffer from a dearth of professional administration and/or strong succession plans. Ultimately, some (like the Barnes, Philadelphia, and the Terra, Chicago) are the victims of their own success—evolving, for better and worse, into larger institutions.

The PMCA's, Jessup points out that one of the greatest challenges boutique museums have is "building awareness." But he is optimistic. He believes that museums like the PMCA provide a key strand in the fabric of art history and art

future because "within their specialty, they can provide a depth of experience and information not found in the larger institutions." This role is crucial, he believes, "in filling in gaps in art history and fostering a closer connection between art and the community."

Will the smaller museums survive and catch hold in America? Only time will tell. But, if you look up, you can see them on a tightrope, teetering between spectacular success and failure.

Ninety-eight

I talk often in this book of the current desire to "reconnect art and life." I am frequently asked why I think they have become so far apart. I have a few opinions.

It may be caused in part by post-modern art's flippant nature (yup, it is art that is consistently hard to relate to on any but the most spurious level).

Another problem is that artists' ranks often fail to represent a nation's poor and minority populations. Adding to this problem, the art world has taken an elitist stance—effectively distancing itself from public ethos. (It follows that the modern world's plethora of popular entertainment options gives the fine arts more than a run for their money—go, Rocky, go!). While many popular artists, from Warhol to Barbara Kruger (and their seemingly infinite number of protégé) ostensibly concern themselves with popular culture/concerns, their work comes across, at best, wry, at its typical worst, pandering.

Many of you share my feeling and have, consciously or not, pushed art to the fringe of your social activities. On the contrary, there has never been such a flourish of growth in the world of art museums and institutions. Attendance records at major exhibitions are setting unprecedented highs. Enrollment in university programs (for careers in art history, "curation," etc.) is on the rise. And there are more artists practicing today than at any other time in history. Moreover, some of the key challenges the world faces (ethnic persecution, religious strife, gender inequities, political upheaval) can be powerfully addressed by artists—not to mention love, beauty, joy.

So why does the rift between our life and the arts seem so palpable? Is there something more countering all of these positives? Perhaps, as many of my friends tell me, we are all just too pressed for time—the contemplative nature of the art experience seems impractical. In a world where we seem

to be getting nowhere fast, this is unfortunate. But, by definition, an art lover like me is an optimist—I believe art in the twenty-first century has much to offer that is both fun and fundamental to our lives. Why not take a minute and have a look?

Ninety-nine

Who is today's most underrated artist? Problem 1: How do we rate artists? Problem 2: See problem 1. Standard criteria, such as "museum holdings" often tell us more about an institution's politics than they do about contemporary artists. Also, an artist's sales and income are not necessarily a direct correlation to his/her talent. This can be said as well for an artist's public relations—especially in the contemporary art world.

Finally, many artists eschew, or are neglected by, major exhibitions that are dominated (for personal and/or business reasons) by "blue chip" artists. There is also the annual publication of *Art Compass* (founded by Dr. Willi Bongard of Cologne) that attempts to rank artist's success by a proprietary point system based on a combination of the aforementioned criterion. It is generally lauded as a source of art investment information—but rightfully maligned as a basis for aesthetic judgments.

Artist and curator opinions would probably be the best source of information but here we are limited by the qualitative nature of their evaluations and lack of a centralized information source that covers the whole of today's art scene. So we are left with opinion—mine and yours. I agree with Dr. Carol Strickland when she cites multitalented artist Jonathan Borofsky (although he has fallen off the radar of late).

I also agree with curator and associate Nancy Silverman's judgment of another American iconoclast, painter James Hayward. I discuss an additional choice, UK based landscape artist George Shaw, elsewhere in this book. Tom Friedman is also on my underrated list—almost certainly because he works in far, far away Northampton, Massachusetts. Tokyo-born Mariko Mori is just one of the Asian born female, multimedia artists, along with Won Ju Lim, and others we should be hearing more about in the future. I

it were possible to be voted onto Bongard's list, I would stuff the ballot for all these wonderful talents. I could not choose one. There are many I have failed to mention. You certainly have your favorites and, in contemplating them, will no doubt think of the unfair vagaries of the art world. But as I have often said, art is not baseball. There is no (and will never be) box score. There will only be opinion—society's and yours. Knowing the source and ramifications of those opinions is key to the future of art.

One Hundred

What will be the challenges facing the fine arts in the future? Of course, we can only guess what's around that corner. If we can see where we are going based on where we are today, the first issue to be faced will be the drastic reduction of funding for arts education and exhibition. Schools and museums all over the world are experiencing government and philanthropic cutbacks on an unprecedented scale. If the well runs dry, does the vine wither? Possibly. Without exposure to arts in schools and free-to-the-public institutions, popular appreciation of art will certainly suffer. On the other hand, history demonstrates that art has a way of clawing out of the darkness . . . some of the greatest bursts of creativity have come out of the most difficult times—the Renaissance (after the Dark Ages) and the modern era (between the great wars), are just two examples.

Another critical situation is art's retreat into two very insular camps—academic and (for lack of a

better term) esoteric. The academics are busy focusing on theory, advanced degrees, fashionable aesthetics, and career politics. Members of the esoteric camp seem to be spending their time dueling one another over the next cutting-edge trend. In sum, "art for art's sake" has become art for the art world's sake. Where will the great communicators of the future come from—the "new, old masters" to use a term from art historian Donald Kuspit? I am heartened by the appointment of Dana Gioia as Chairman of the National Endowment for the Arts. He has successfully made this argument in the world of poetry, and he is working now to inspire a greater dialogue in all the arts.

Moving on, race and place are imminent artistic crossroads. Ethnic, third world, and outsider artists, historically disenfranchised, will rise up. If embraced, we may witness a great flowering of the global art garden. If not, we may face an

increasingly frustrated and polarized art world. A seemingly innocuous issue that we face today—that I consider a bad omen—is what I call the critic vacuum.

From Vasari to Greenberg, the art world has been often enlightened by "firsthand" journalists who were not afraid to give their opinion. Today, mega print media monopolies, focusing on the bottom line, provide little to no print space for in-depth art review. TV, radio and, surprisingly, new media, (surprising because of the cheap access they can provide for critical opinion) are equally barren. Decent critics, when they can be found, perhaps frustrated with their shrinking audience or fearful of hurting their peer's feelings, have become little more than art world lackeys—taken by artists and the public with a grain of salt. Bleak indeed. But there are a number of contemporary journalists fighting the good fight. A few examples are David Pagel of the *Los Angeles Times*, Pete

Frank of *ArtNews*, Edward Goldman of *NPR*, the straight-talking Lee Rosenbaum of the *Wall Street Journal*, and the wry, Matt Groening-esque genius of Coagula's Mat Gleason. They know that the critic's job is to cut through esoteric pretension. They illuminate and enliven—effectively revealing art (and the art world) to society at large.

The space here allows for just one more issue (though there are many out there). Technological change will continue to amaze and frustrate. For artists, the dizzying pace makes any practical expertise/career in a given medium nearly impossible. Video is a perfect example. Videotape came and went faster than the time needed for artists to master it. Will digital art suffer the same fate? And art lovers, faced with a myriad of new opportunities to experience art (from the proliferation of novel exhibitions to the Internet), are often intimidated and uninspired.

But, just as the present always gives us cause fo
alarm, the past gives us reason to hope. Art is a
old as humankind and has always overcome grea
challenges. So many of the great artists I hav
admired and artist friends today give me reaso
to believe that the old phrase—"When the goin
gets tough, the tough get going."—may be attrib
uted to them. I may be naïve, but my love of ar
inspires me to speak of a bright future filled wit
artistic wonders. Perhaps this is what every artis
from every generation has been trying to tell u
all along.

One hundred and one

What is the most important thing we can do to ensure a future for the fine arts? I have a confession. This book should have been called *100 Things I Don't Know About Art*. I guess there is one thing I do know. Fine art's future will not be secured by academics—by reviewers—by check writers. Of course, it falls to the artists; but it also falls to you, the viewer. Visit. See. Embrace. Love. Hate. Discuss. That's it. You inspire the future by engaging. It may seem strange to end a book on fine art with the words of a pop song, but these words by Robert Hunter ring so true here: "You don't have time to call your soul a critic/ Wake up to find out that you are the eyes of the world."

Great Resources

About Looking by John Berger

Absolutearts.com

After Cézanne by Clive Bell

An Uncommon Vision, The Des Moines Art Center

Art Forum Magazine

Art History After Modernism by Hans Belting

Art In America

ArtLex.com

ArtNews

Art Now published by Taschen

Art of the Twentieth Century by Karl Ruhrberg, Manfred Schneckenburger, Christiane Fricke, Klaus Honnef

Black Art and Culture in the Twentieth Century by Richard J. Powell

Contemporary Art: A Sourcebook of Artists' Writings, edited by Kristine Stiles and Peter Selz

Conversations With Cezanne edited by Michael Doran

Duane Hanson More Than Reality edited by Buchsteiner and Letze

Foci: Interviews With 10 Curators by Carolee Thea (foreword by Barry Schwabsky)

History of Modern Art by H. H. Arnason

Inside The White Cube, Brian O'Doherty

Installation Art In the New Millennium by Oliveeira, Oxley, and Petry

Julien Levy: Portrait of an Art Gallery by Ingrid Schaffner

Landscape With Figures by Malcom Goldstein

Michelangelo's Pieta by Jack Wasserman

Modern Painters magazine

Most Art Sucks: Five Years of Coagula, ed., Mat Gleason, published by Smart Art Press

My Galleries and Painters by Daniel Henry Kahnweiler

New Perspectives In Painting published by Phaidon

Nine Famous Artists Your Children Will Love by Michael E. Napoliello, Jr.

Portrait of Dr. Gachet by Cynthia Saltzman

The Annotated Mona Lisa by Carol Strickland, Ph.D.

The Art Dealers, Laura De Coppet, et al.

The Artist Outsider edited by Michael Hall, Roger Cardinal, Eugene Metcal

The End of Art by Donald Kuspit

The Invention of Art by Larry Shiner

The Square Halo by Sally Fisher

Theories of Modern Art: A Source Book by Artists by Herschel B. Chipp

Theory and Philosophy of Art: Style, Artist and Society by Meyer Schapiro

Thinking About Exhibitions edited by Reesa Greenberg, Bruce Ferguson and Sandy Nairne

Timeline Book of the Arts, George Ochoa and Melinda Corey

Tracking The Marvelous, John Bernard Myers

True Colors by Anothony Haden-Guest

Twentieth Century Artists on Art by Jack Robertson

Understanding Painting, Alexander Sturgis and Hollis Clayson

What Is Modern Painting, Alfred Barr, Jr.

Why Art Cannot Be Taught by James Elkins

Words of Wisdom: A Curator's Vade Mecum on Contemporary Art, published by Independent Curators International

Index

About the Author

Michael Napoliello Jr. is co-founder of Gallery C, a Southern California art gallery specializing in contemporary California artists. He has been involved with the arts since his University of Maryland days where he ran an emerging artists gallery and, through the 1980s, as owner and editor of the *Wave*, a newspaper devoted to the arts and leisure.

Mr. Napoliello has written several other books including: *Nine Famous Artists Your Children Will Love* and *Grand Fanatics*, as well as several books of poetry including: *Pop Poems*, *Landscape With Graffiti*, and (forthcoming from Literary Press) *Pomes, Revised Selected & New*.

He is also Chairman of SkyBridge Private Air, a founding Board Member of the Pasadena Museum of California Art, and a member of the LA County Museum of Art's Collectors Committee.

He can be reached at Mike@galleryc.com.